COLOR COU Y

Touring the Colorado Plateau

SUSAN M. NEIDER

FALCON®

GUILFORD, CONNECTICUT
HELENA, MONTANA
AN IMPRINT OF THE GLOBE PEQUOT PRESS

Ice-frosted grass

TO MY WONDERFUL DAUGHTER, ANNIE

Photo credits: Photos on pages 12, 34, 54, 76, and 88 (bottom) by Daniel M. Levine. Photos on pages 28 (bottom) and 78 (top) by Annie N. Donnelly. All other photos are by the author.
Text design by MaryAnn Dubé
Maps created by Daniel M. Levine

Library of Congress Cataloging-in-Publication Data
Neider, Susan M.
 Color Country : touring the Colorado plateau / Susan M. Neider. — 1st Globe Pequot
Press ed.
 p. cm.
 ISBN: 0-7627-3646-1
 1. Colorado Plateau—Tours. 2. National parks and reserves—Colorado
Plateau—Guidebooks. I. Title.

F788.N45 2005
917.91'30454—dc22 2004054186

Manufactured in China
First Globe Pequot Press Edition/First Printing

CONTENTS

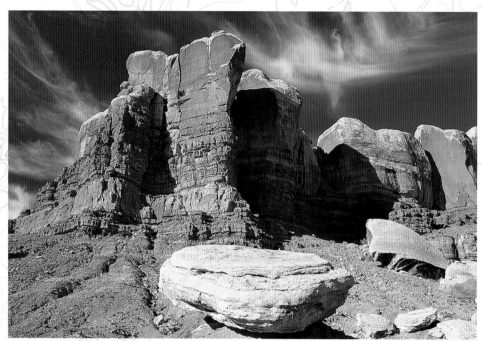

Between Blanding and Bluff, Utah

WHAT LAY AND UPREARED AND HID BEYOND THAT LEVEL OF
RANGELAND WAS THE THING THAT CHANGED SUE'S GAZE. IT WAS THE
CANYON COUNTRY OF UTAH. LONG SHE HAD HEARD OF IT, AND NOW IT
SEEMED TO SPREAD OUT BEFORE HER, A VAST SHADOWY REGION OF
ROCK-DOMES, SPURS, PEAKS, BLUFFS, REACHING ESCARPMENTS, LINES
OF CLEAVAGE, ENDLESS SCALLOPED MARCHING ROCKS. . . .

—ZANE GREY, *WILD HORSE MESA* (1924)

PREFACE

I wrote this book about the Colorado Plateau for one simple reason: I love the place. I love its unearthly beauty, its fantastic shapes and intense colors of every imaginable hue, such as in brilliant and shocking Red Canyon, a hidden surprise just west of Bryce. I love its wild light, which can change so capriciously, transforming a place in a matter of seconds, and then disappear. I love the rush of land as it rolls under me, while all around, elements of line, form, and color shift in great shadowy waves as I travel across its empty roads. I love the perspective, the long sweeping views that stretch unbroken for hundreds of miles. I can run my eyes along the curvature of the earth and follow the face of the map from the San Miguel and La Plata Mountains all the way to Monument Valley, or see the entire length of the Grand Staircase unfold before me from an overlook high up in Dixie National Forest. The intimacy, too, I love, like the tiny sandstone tracings etched in nature's finest ink, discovered quite by accident in the rock along the Hogsback above the Canyons of Escalante.

I love this place because it is so weird and unusual, so unlike any other place I know. It is a place of outrageous thunderheads, where the bottoms of the clouds are pink from the red rock reflected skyward, or where a long gray shaft of rain, carried by the wind, bends toward earth. It is a place where a frozen cloud touches ground for an instant, and leaves behind the finest dusting of white powder on every blade of desert grass. Or where a mule deer casually jumps over a car as it approaches. I love this place for its sense of humor, for its power to surprise even the most jaded observer. It is impossible to predict the weather, the skies, the sunsets, or how to pack sensibly. Ask anyone chasing photographs and they will tell you that nature always has the last laugh.

I love the remoteness of this place, and its overwhelming immensity, where sound is swallowed up by impenetrable silence. One shout from Grandview Point in Canyonlands will prove that. I love this place for being honest about the fact that it is a brutal and ruthless wilderness, and I'm glad it reminds me of that every now and then. It cares not a thing about my opinions or wishes; it cares only that I leave it alone, as I found it.

Perhaps most of all, I love this place for its permanence. Although it is constantly changing, I find comfort in its wisdom of the ages, its resistance to change. I can return to a single spot again and again and find it always looks different: ablaze with wildflowers, drenched with rain, shrouded in fog, scorched from fire. It may wear many different outfits, but at its heart, it is always the same. And I thank this place for how it makes me feel, that it makes me wonder and imagine. I wish for you the same.

How to Use
This Book

What is the Colorado Plateau? In brief and simple terms, the Colorado Plateau is a vast and uplifted region of the American Southwest that has been created by the complex Colorado River system cutting down into rising land. Immense at 130,000 square miles, its beauty and diversity are unmatched: mountains, forest, desert, rivers, plateaus, canyons, and an extraordinary variety of geologic formations.

LOCATION: A quick reference for the park's location relative to the nearest town

ELEVATION: Highest and lowest points within the park boundaries

NAME: Derivation or translation, if any

AREA/LOCAL MAPS: Illustrative guides to major roads, trails, geologic features, and park offerings. Some maps and photo captions are marked with corresponding numbered camera icons (⬛4). These icons identify locations on the map where specific photographs were taken.

GEOLOGY: A brief description and explanation of the important geologic features unique to that park

SUGGESTED LENGTH OF STAY: This should allow for ample opportunity to tour the park and revisit favorite spots. Some parks are so large and diverse that additional time will be needed for a thorough exploration or for specialized activities such as backcountry hiking and river rafting expeditions.

BEST TIME TO BE THERE: It is generally true that landscape photographers prefer early morning or evening light for its brilliance, clarity, and saturation. Midday light tends to be harsh, flat, and brutally hot in the summer.

HIGHLIGHTS: Each park's "greatest hits" according to the author

COLORFUL NOTES

Unusual or little-known facts about the park

COLORFUL COMMENTS

Little-known quotations describing the wonder and beauty of the park

GENERAL INFORMATION

- **FEE (YES OR NO):** Is any fee required to enter this park?

- **VISITOR CENTER:** Each park's official focal point for information, maps, books, and museum displays. The facility may range from a small, simple structure to a large, complex information plaza complete with talks, movies, guided nature walks, and Junior Ranger programs. The visitor center is always an essential stop in the park.

- **4WD NEEDED (YES OR NO):** Is a four-wheel-drive vehicle necessary to see most of the scenic areas in the park?

- **GAS WITHIN 5 MILES (YES OR NO):** Is gasoline available within 5 miles of this park?

- **RESTROOMS:** Are restrooms available? (Some parks may not have flush toilets or running water.)

- **FOOD/WATER (YES OR NO):** Are drinking water and, at the minimum, a light snack available within or very near the park?

- **CONVENIENCE STORE (YES OR NO):** Does the park have a general store where basic rations and supplies can be purchased?

- **HIKING (YES OR NO):** Is hiking permitted in this park?

- **CAMPING (YES OR NO):** Is overnight camping permitted in this park?

- **LODGING WITHIN 5 MILES (YES OR NO):** Are basic hotel services available within 5 miles of this park?

- **PHOTO RATING (1 LOW–5 HIGH):** This rates the relative ease with which an advanced amateur can come away with a variety of striking and satisfying images. Some parks contain regions that are very beautiful, but also very remote. If important scenic areas are difficult or dangerous to access, the photo rating will drop no matter how stunning they may be.

- **CHILD RATING (1 LOW–5 HIGH):** This rates the relative appeal to the curiosity and imagination of children ages 6 to 12, based primarily on fun activities, interactive displays, and educational content.

NOTE OR CAUTION: Additional important information or warnings

FOR MORE INFORMATION

Complete contact information for each park

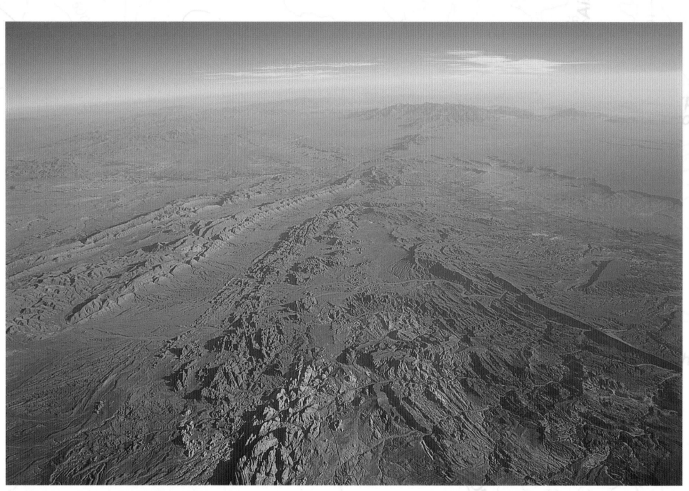

Looking north over the Colorado Plateau

FORMATION
of the Colorado Plateau

DURING THE EARTH'S CRETACEOUS PERIOD (144 MILLION TO 63 MILLION YEARS AGO), A VAST INLAND SEA EXTENDED NORTHWEST FROM THE GULF OF MEXICO INTO CANADA, COVERING THE REGION NOW CALLED THE COLORADO PLATEAU. THE SEA DEPOSITED LAYER AFTER LAYER OF SEDIMENT INTO ITS BASIN AS IT REPEATEDLY WASHED OVER AND FLOWED AWAY FROM THE REGION. WITH EACH CYCLE CAME GREAT FLUCTUATIONS IN THE CLIMATE AND ENVIRONMENT.

As a result, each wave of sedimentation laid down deposits that varied in thickness, composition, color, and, of course, age, the deepest strata being the oldest. In some areas, shallow layers thinned out to the point of vanishing under the sheer weight of the accumulated debris.

Eventually the inland sea retreated for the last time. Water rich in minerals such as iron oxide and calcium carbonate slowly filtered through the deposited sediment, gradually settling and cementing the compressed layers, transforming them into stone. What was once windblown sand became sandstone, the sea basin became limestone, and mud and clay turned to shale.

Then about ten million years ago, in certain areas along north-south fault lines, a tremendous geologic upheaval occurred, buckling and uplifting huge sections of the earth's crust. Layers of rock, once continuous, were jumbled, inverted, or displaced vertically by thousands of feet. In the thrust upward, the sunken basin was filled with long plateaus and broad concave swells, which rose up only to fall away and rise again in every direction toward the distant highlands.

With upheaval comes erosion, for uplift gives water greater canyon-cutting power in its rush and tumble descent to the sea. It scours, it scrapes, it dissolves, it seeps into joints, cracking them open by repeated freezing and thawing. It weathers softer rocks faster than hard ones and washes them away at different rates, increasing the disorganization. Relentless wind adds its fury, whipping up sand and dust to batter the weakened stone. Weathered and unstable, entire rock structures yield to gravity and collapse into rubble. High plateaus formed with steep, fractured edges that were especially vulnerable to erosion and crumbled away, for example, into the jagged cliffs of the Grand Staircase in southern Utah.

Over the ages emerged a vast landscape of extremes and contradictions: arid, lush, brutal heat, bitter cold, torrential flooding over parched earth, snowy peaks rising suddenly from burning desert sand, howling wind, stillness, order from a distance, chaos in the details, immense emptiness, infinite in complexity. Space, time, expanse, silence.

Shown on the following pages is a geological profile of the Colorado Plateau, a giant, mile-high, tilted rock table, that sprawls over 130,000 square miles. Its story is written in rock strata, and they appear in the margins in colors that approximate their natural hues. Typical shapes from nine important groups are listed on the first page. Guidelines and corresponding photographs from the chapters that follow serve to match various locations to the profile.

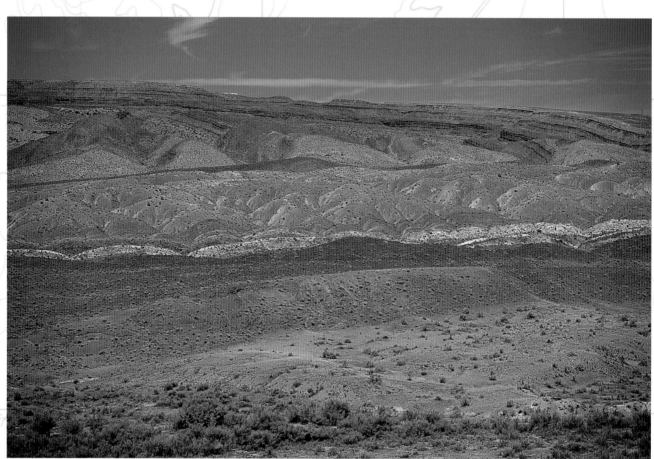

Comb Ridge, near Four Corners

GEOLOGY
of the Colorado Plateau

CLARON FORMATION: delicate spires and pinnacles

ENTRADA SANDSTONE: strangely eroded shapes, arches, fins, and domes

NAVAJO SANDSTONE: massive domes, sheer cliffs, and pale slickrock

KAYENTA FORMATION: ledges, arches, and "swiss cheese" walls; often caps Wingate cliffs

WINGATE SANDSTONE: sheer vertically cracked cliffs, usually on a Chinle formation base

CHINLE FORMATION: rock-littered slopes at the base of Wingate cliffs, mounds and ripples with multiple bands of color

MOENKOPI FORMATION: towers and steep slopes with ridges and ledges

CEDAR MESA SANDSTONE: upright cliffs and natural bridges

CUTLER FORMATION: weathers into columns, towers, and "standing rocks"

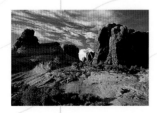

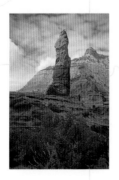

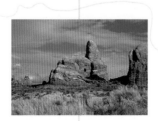

CLARON
FORMATION
600'

MANCOS SHALE
3,500'

(NOT TO SCALE)

DAKOTA
SANDSTONE
350'

MORRISON
FORMATION
400'

SUMMERVILLE
FORMATION
300'

ENTRADA SANDSTONE
150'

ENTRADA SLICKROCK
350'

ENTRADA SANDSTONE
100'

65 MILLION YEARS OR LESS

135–65 MILLION YEARS

195–136 MILLION YEARS

CAPITOL REEF NATIONAL PARK

ARCHES NATIONAL PARK

3

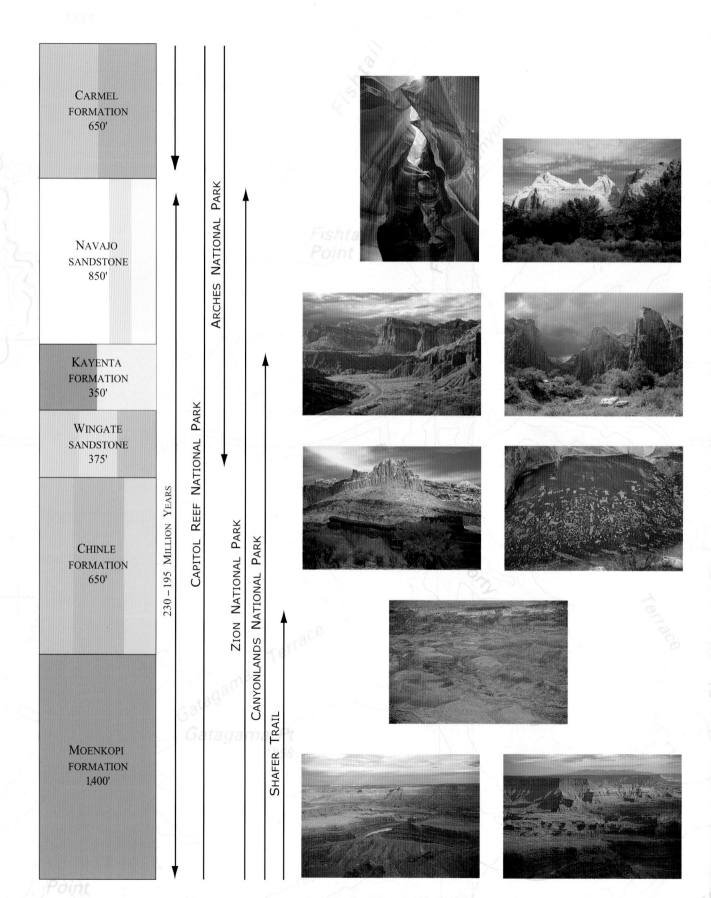

CARMEL
FORMATION
650'

NAVAJO
SANDSTONE
850'

KAYENTA
FORMATION
350'

WINGATE
SANDSTONE
375'

CHINLE
FORMATION
650'

MOENKOPI
FORMATION
1,400'

230 – 195 MILLION YEARS

CAPITOL REEF NATIONAL PARK

ARCHES NATIONAL PARK

ZION NATIONAL PARK

CANYONLANDS NATIONAL PARK

SHAFER TRAIL

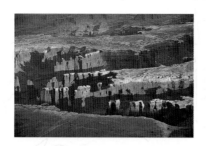

KAIBAB LIMESTONE
300'

WHITE RIM SANDSTONE
250'

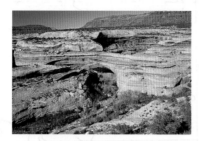

CEDAR MESA
SANDSTONE
1,200'

285 – 230 MILLION YEARS

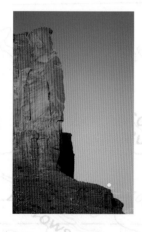

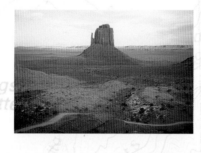

CUTLER
FORMATION
1,400'

CANYONLANDS NATIONAL PARK

SHAFER TRAIL

GRAND VIEW POINT

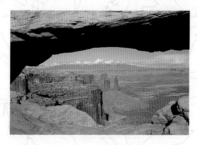

HONAKER TRAIL
FORMATION
3,000'

(NOT TO SCALE)

320 – 285 MILLION YEARS

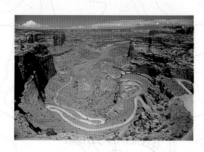

PARADOX SALT
5,000'

(NOT TO SCALE)

Colorado River

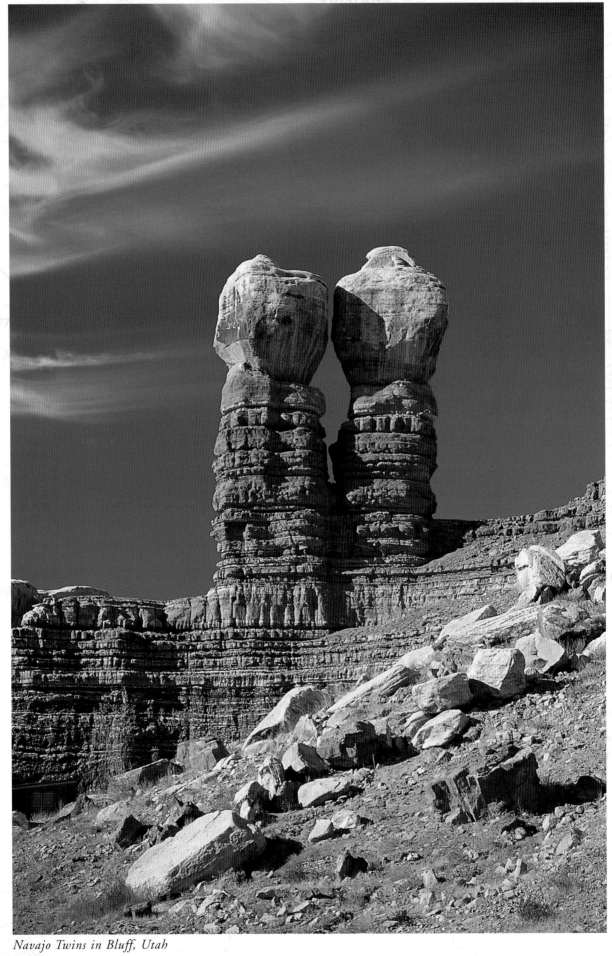

Navajo Twins in Bluff, Utah

Traveling the
COLORADO PLATEAU

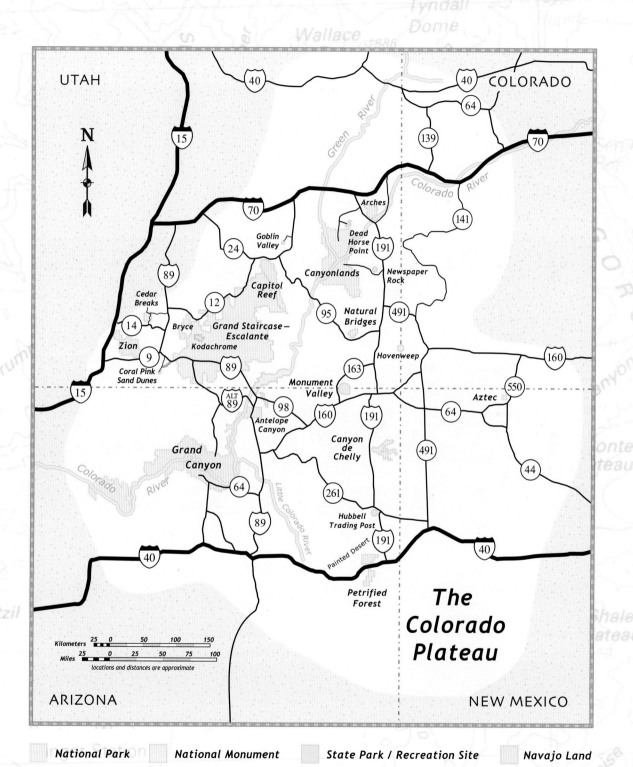

UTAH

N

COLORADO

40

40

64

139

70

15

Green River

Colorado River

70

Arches

141

Goblin Valley

24

Dead Horse Point

191

Canyonlands

Newspaper Rock

89

Capitol Reef

Cedar Breaks

12

95

Natural Bridges

491

Bryce

Grand Staircase–Escalante

14

Zion

Kodachrome

Hovenweep

160

9

89

Coral Pink Sand Dunes

163

550

15

ALT 89

Monument Valley

Aztec

98

160

191

64

Antelope Canyon

Grand Canyon

Canyon de Chelly

491

64

89

Little Colorado River

261

44

Hubbell Trading Post

191

40

Painted Desert

40

Petrified Forest

The Colorado Plateau

Kilometers 25 0 50 100 150

Miles 25 0 25 50 75 100

locations and distances are approximate

ARIZONA

NEW MEXICO

National Park National Monument State Park / Recreation Site Navajo Land

7

High-centered vehicle

GENERAL PRECAUTIONS

CLIMATE

HEAT—Blistering summer temperatures in the southern lowlands can exceed 100°F, and sometimes there is no protective shade; summer nights can dip below freezing at higher elevations.

DRYNESS—Humidity can drop below 10 percent in the barren desert regions near the Four Corners.

WIND—The powerful erosive force of constant wind can irritate skin, eyes, and lungs, and destroy photography equipment.

SUN—Brilliant and strong, so skin, lips, nose, and eyes need protection year-round. The sun's ultraviolet rays increase in intensity about 5 percent for every gain of 1,000 feet in elevation.

DANGEROUS CREATURES

Contact with diseased or poisonous animals, insects, and plants requires immediate medical attention.

DEHYDRATION

A minimum of 2 quarts of water per person per day is recommended for normal activity. Do not drink spring or stream water—no matter how pure it appears—unless it has been boiled for at least five minutes to destroy *Giardia lamblia* bacteria.

ELEVATION

Altitude sickness, especially at elevations above 8,000 feet, can cause headaches, nausea, swelling, insomnia, rapid heart rate, and shortness of breath. Rest, noncaffeinated fluids, carbohydrates, and descent to lower altitude will bring some relief. For every gain of 1,000 feet in elevation, the temperature will drop approximately 4°F, the equivalent of traveling north about 600 miles.

REMOTENESS

Do not hike alone, and always inform a park ranger (or other authority if outside park boundaries) of your itinerary. If you become lost, stay where you are. Cellular and wireless phones are often useless, for there may be no existing communication cells.

RULES AND REGULATIONS

Obey and respect all posted or published park regulations and recommendations. Do not feed animals, disturb wildlife, or remove rocks, wood, plants, artifacts, *anything*. Stay on marked trails only. Do not walk on fragile cryptobiotic soil, a complex and important component of the desert ecosystem that resembles brittle, knobby, black dirt. Actually, this biological soil crust is very much alive, composed primarily of cyanobacteria along with lichens, mosses, microfungi, green algae, and various other bacteria. Take only pictures, and leave no trace of your presence.

SERVICES

Park services may be limited from October through May and strained under the press of tourist crowds during the summer. Gasoline stations, medical services, and food and water stops are few and far between in remote areas.

UNSTABLE GROUND

Sandstone slickrock and weathered rock on cliff edges can break off without warning, especially near sheer drop-offs.

WEATHER

Weather can change quickly, dramatically, and without warning. Sudden thunderstorms can trigger deadly lightning and flash floods throughout the mountains and canyons. Do not enter *any* canyon or streambed if the skies are ominous or the threat of rain exists.

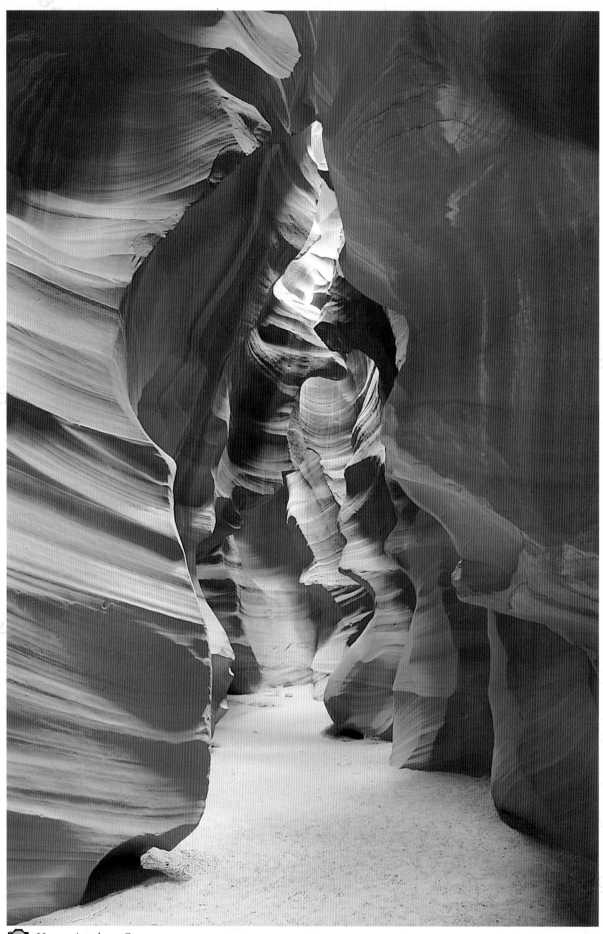

1 *Upper Antelope Canyon*

ANTELOPE CANYON
(Upper)

LOCATION: Near Page, Arizona, within the LeChee Chapter of the Navajo (Dineh) Nation

ELEVATION: 4,000 feet

NAVAJO NAME: *Tse Bighanilini*—"the place where water runs through rocks"

AREA MAP: The entrance to Upper Antelope Canyon is located about 2.1 miles east of Page, Arizona, just past Mile Marker 299 on AZ 98.

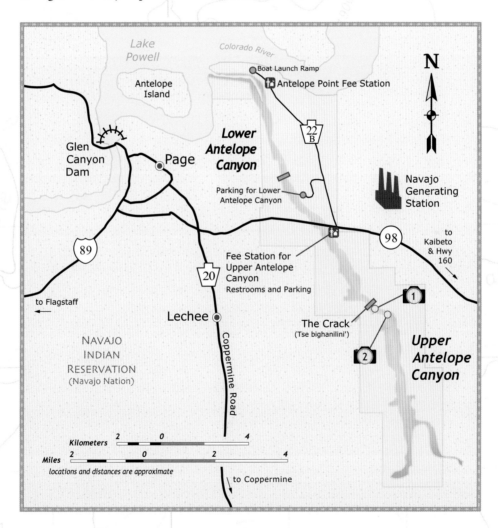

GEOLOGY: Upper Antelope Canyon is a "slot," or jagged crack, carved by wind and rushing water into golden Navajo sandstone by a tributary of the Colorado River on its course to Lake Powell. The fluid curves of its sculpted walls rise 120 feet from the sandy floor, but the canyon is so narrow that in places both sides can be touched at once.

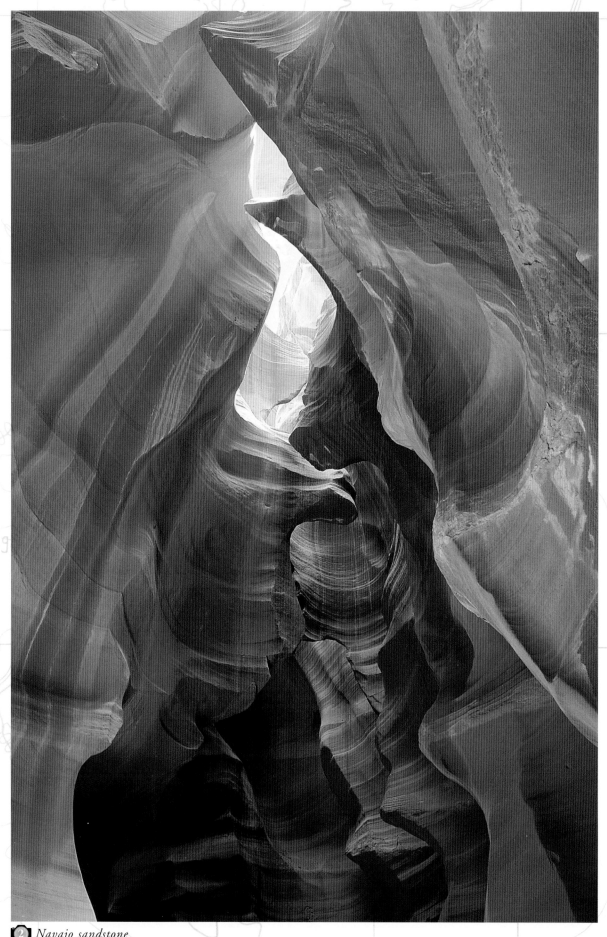

2 *Navajo sandstone*

ANTELOPE CANYON
(Upper)

SUGGESTED LENGTH OF STAY: 3 to 5 hours

BEST TIME TO BE THERE: Under cloudless skies between 10:00 A.M. and 3:00 P.M.

HIGHLIGHTS: When the sun floods the canyon, the sinuous, swirling walls glow with color, twisting in crimson, magenta, violet, and salmon pink. Dusty shafts of light pour in and ignite the flaming waves of rock. It is no small challenge to photograph within this shadowy corridor, to capture the range of light and the rhythm of its forms, but effort is rewarded with stunning results. Equipment should include a reliable camera, tripod, plenty of slow film, lenses ranging from 24mm to 100mm, lens hoods, cable release, canned air, extra batteries, flashlight, and plastic bags to protect equipment from falling sand. Careful choice of focal points using maximum depth of field is essential. Bracket exposures generously and allow for reciprocity failure. Come prepared, especially with water and a light jacket, for a Navajo guide is likely to leave you at the canyon entrance and not return for at least several hours.

COLORFUL NOTE

Movies filmed in the slot canyons include *Beast Master II*, *Broken Arrow*, *Highway to Hell*, *Lightning Jack*, and *Raven Hawk*.

GENERAL INFORMATION

FEE:	Yes	**CONVENIENCE STORE:**	No
VISITOR CENTER:	No	**HIKING:**	No
4WD NEEDED:	No	**CAMPING:**	No
GAS WITHIN 5 MILES:	Yes	**LODGING WITHIN 5 MILES:**	Yes
RESTROOMS:	Yes	**PHOTO RATING (1–5):**	5
FOOD/WATER:	No	**CHILD RATING (1–5):**	2.5

CAUTION: Do not enter Upper Antelope Canyon if there is a chance of rain. Flash floods can be deadly in these narrow slots.

FOR MORE INFORMATION

Antelope Canyon Navajo Tribal Park
P.O. Box 4803
Page, AZ 86040
(520) 698–2808
www.navajonationparks.org

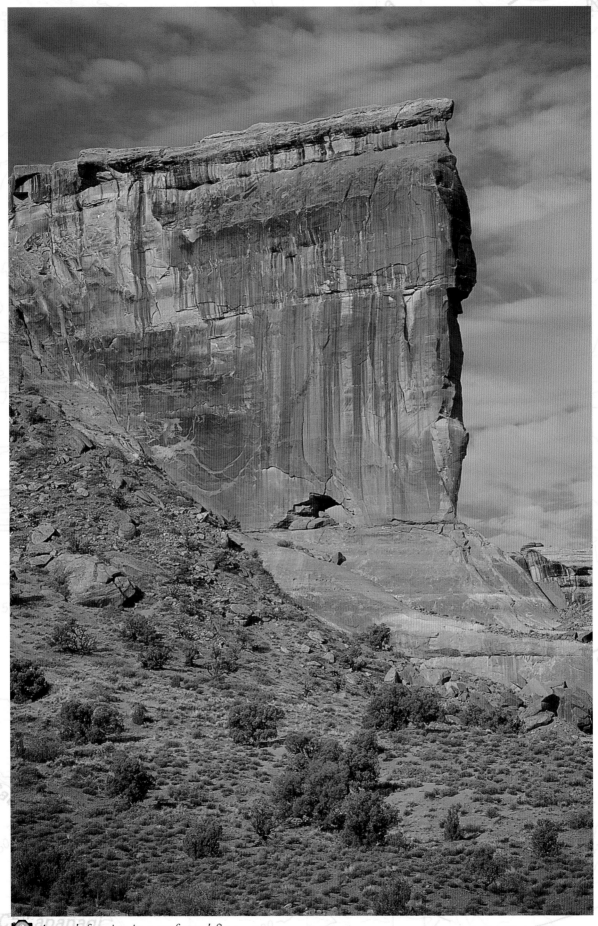

3 *An arch forming in a perforated fin*

ARCHES
National Park

LOCATION: Near Moab, Utah

ELEVATION: Ranges from about 4,000 feet along the Colorado River to 5,653 feet at the top of Elephant Butte

AREA MAP: Arches National Park is located 5 miles north of Moab, Utah, on US 191.

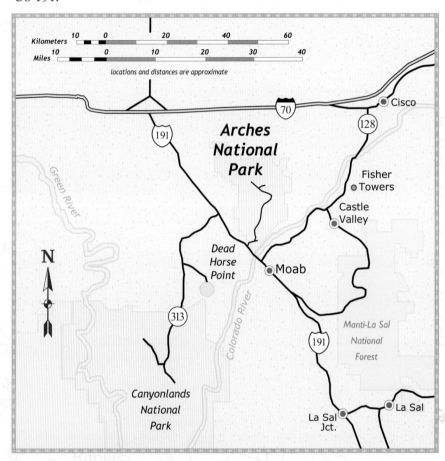

GEOLOGY: What was once a 300-foot layer of Entrada sandstone has been sculpted over the ages by gravity, water, and ice into a geologic wonderland called Arches National Park. It is most famous for its more than 2,000 stone arches created by the weathering away of perforations broken through massive vertical slabs of sandstone called fins. To be classified as an arch, the opening must extend at least 3 feet in any one direction, and the park contains the world's largest concentration. Deep beneath this surface layer of sandstone lies an unstable salt bed laid down by ancient seas that once filled a huge depression called Paradox Basin. The salt became plastic, buckling and bulging under the tremendous pressure of the rock above it. These violent forces fractured the overlying sandstone, producing fantastic spires, domes, pillars, fins, rugged undulating slickrock, and boulders that balance atop impossibly meager supports.

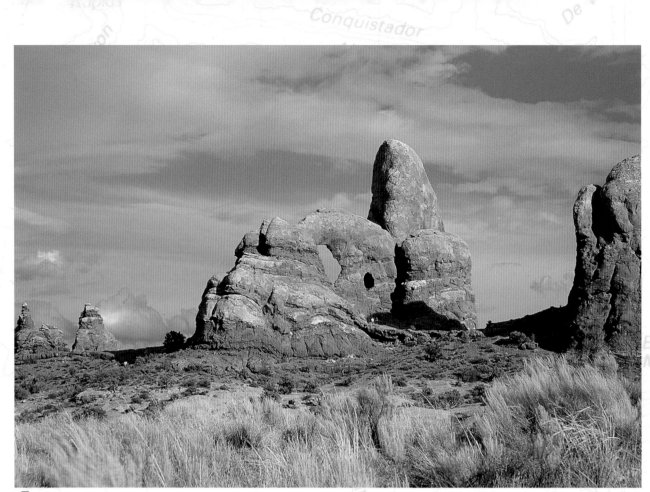

4 *Turret Arch in the Windows Section*

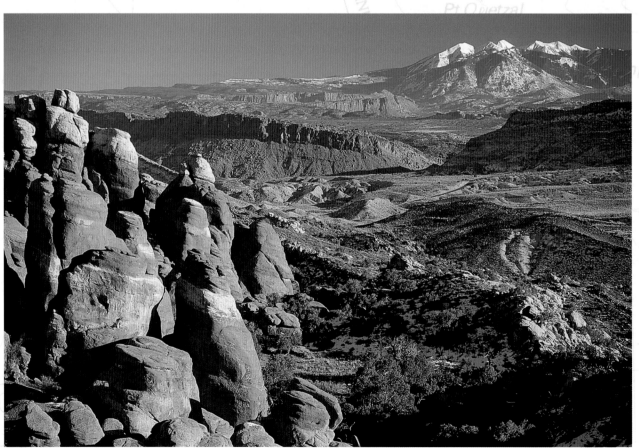

5 *Fiery Furnace and the Salt Valley*

ARCHES
National Park

LOCAL MAP

N

EAGLE PARK

DEVILS GARDEN

Private Arch
Wall Arch
Dark Angel
Pine Tree Arch
Double O Arch
Navajo Arch
Tunnel Arch
Clover Canyon
Partition Arch
Landscape Arch
Campground
Skyline Arch
Broken Arch
Tower Arch
Marching Men
Sand Dune Arch
KLONDIKE BLUFFS
FIERY FURNACE
Lost Spring Canyon
Salt Wash

to 70

⑤ Fiery Furnace Viewpoint
Salt Valley Overlook
Delicate Arch
Wolfe Ranch
Delicate Arch Viewpoint

191

Panorama Point

Eye of the Whale Arch

Ham Rock ④
Elephant Butte
Cove of Caves
Double Arch
Willow Flats
Balanced Rock
Cove Arch
North and South Window
Parade of Elephants
Turret Arch
THE WINDOWS SECTION

to Dead Horse Point State Park and Canyonlands National Park Island in the Sky District

313

⑥
Petrified Dunes Viewpoint
PETRIFIED DUNES

③
Tower of Babel
Sheep Rock
Courthouse Towers Viewpoint
Three Gossips
The Organ
COURTHOUSE TOWERS
La Sal Mountains Viewpoint
Park Avenue
⑦

128

THE GREAT WALL

Colorado River

Kilometers 2 0 4 8 12
Miles 2 0 2 4 6 8

locations and distances are approximate

VISITOR CENTER

191

279

Moab

to Canyonlands National Park Needles District and Monticello

to Potash

- - - - TRAIL
= = = = 4-WHEEL-DRIVE ROAD
———— UNPAVED ROAD

17

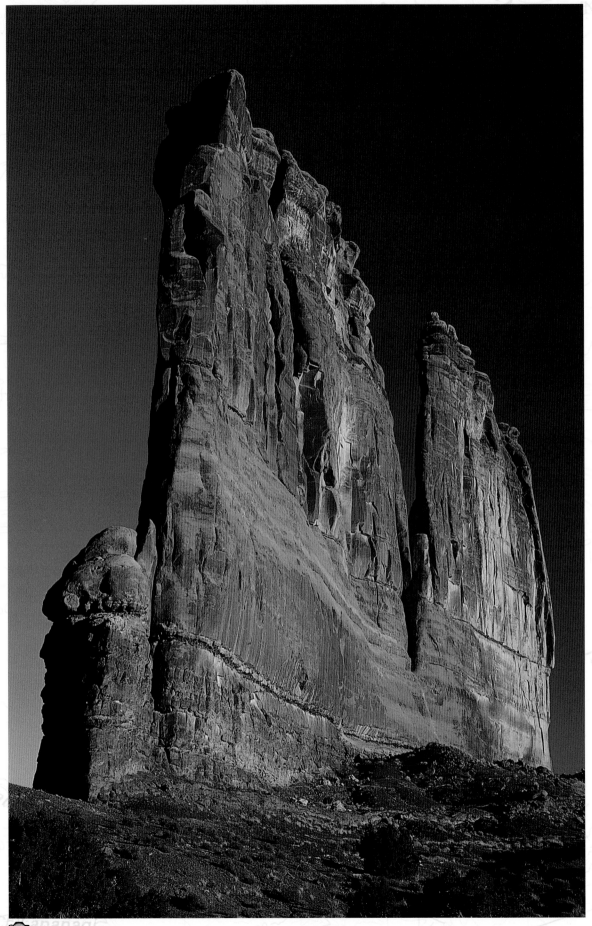

6 *The Organ*

SUGGESTED LENGTH OF STAY: 2 to 3 days

BEST TIME TO BE THERE:

• **Early morning:** Double Arch, Double O Arch, Landscape Arch, North and South Windows from the east, the Organ, Sheep Rock, the Three Gossips, Turret Arch, Wolfe Ranch

• **Late afternoon:** Balanced Rock, Courthouse Towers, Delicate Arch, Fiery Furnace, Fins in Devils Garden, North and South Windows from the west, Park Avenue, Petrified Dunes, Skyline Arch, Tower Arch

HIGHLIGHTS:

• **Balanced Rock:** The world-famous impossibility

• **Delicate Arch:** A strenuous 3-mile round-trip climb from Wolfe Ranch ascends to this beautiful, slender arch perched on the edge of a slickrock bowl. Its stark form is different from other arches in that it is absolutely freestanding, not spanning other rock. In the distance lie the Cache Valley and the La Sal Mountain Range. In silhouette against a rising sun, Delicate Arch glows scarlet red at sunset. Carry plenty of water, for there is no shade in this open slickrock expanse.

• **Landscape Arch in Devils Garden:** An easy 2-mile round-trip trail leads to one of the world's longest known arches, soaring 105 feet overhead with a span of 306 feet. On September 1, 1991, a 60-foot slab broke away, leaving this gravity-defying arch even thinner and threatening to collapse.

• **Park Avenue:** A steep descent leads to a 1-mile round-trip trail into a redrock canyon with walls of fins and balanced rocks that tower like sandstone skyscrapers.

• **The Windows Section:** In this most spectacular and accessible region of the park, four large arches can be reached by a short walk from the main road: Turret Arch, North and South Window, and the amazing Double Arch.

COLORFUL NOTE

Movies filmed within Arches National Park include *Taza, Son of Cochise* (1953), *Ten Who Dared* (1959), *Cheyenne Autumn* (1963), *Rio Conchos* (1964), *Against a Crooked Sky* (1975), *Indiana Jones and the Last Crusade* (1988), and *Thelma and Louise* (1991).

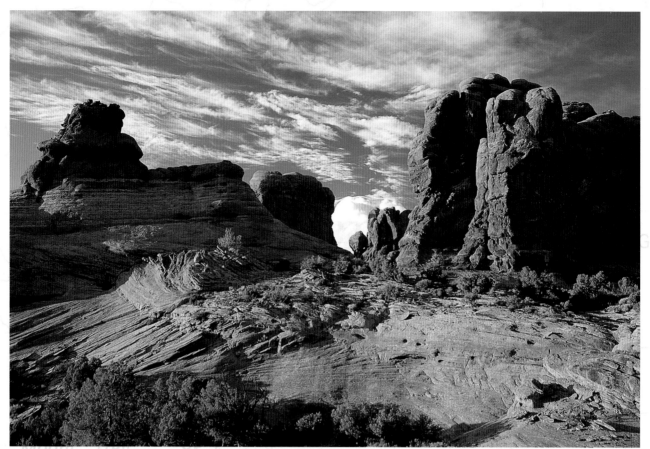

Slickrock and domes

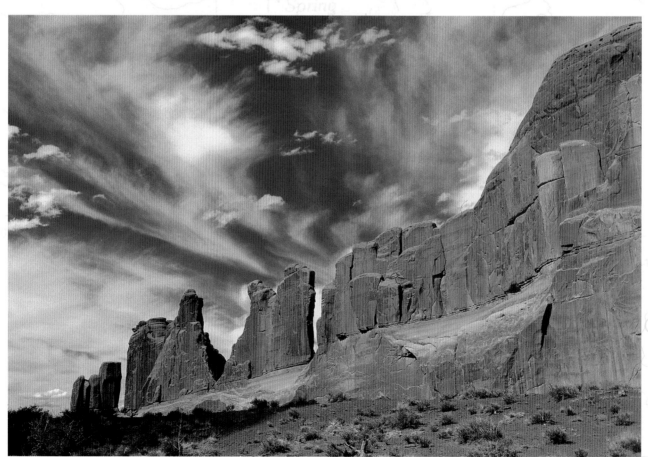

7 *Park Avenue*

COLORFUL COMMENT

In his enduring personal account *Desert Solitaire, A Season in the Wilderness,* author Edward Abbey reflects on his experiences as a ranger in Arches National Park during the late 1950s:

> IF DELICATE ARCH HAS ANY SIGNIFICANCE IT LIES, I WILL VENTURE, IN THE POWER OF THE ODD AND UNEXPECTED TO STARTLE THE SENSES AND SURPRISE THE MIND OUT OF THEIR RUTS OF HABIT, TO COMPEL US INTO A REAWAKENED AWARENESS OF THE WONDERFUL—THAT WHICH IS FULL OF WONDER.

GENERAL INFORMATION

FEE:	Yes	CONVENIENCE STORE:	No
VISITOR CENTER:	Yes	HIKING:	Yes
4WD NEEDED:	No	CAMPING:	Yes
GAS WITHIN 5 MILES:	Yes	LODGING WITHIN 5 MILES:	Yes
RESTROOMS:	Yes	PHOTO RATING (1–5):	3.5
FOOD/WATER:	Yes	CHILD RATING (1–5):	3.5

CAUTION: Hike carefully on sandstone slickrock, for it may crumble and give way underfoot. Protect fragile cryptobiotic soil crust by walking only on hard rock or marked trails. Climbing on the arches is prohibited. Rock climbing is allowed, but is limited to features *not* named on USGS maps. Getting back down after an ascent is often impossible, leaving the climber stranded, forcing an expensive and dangerous technical rescue. Mountain bikes are permitted on the main roads only and not on trails or in the backcountry.

FOR MORE INFORMATION

Superintendent
Arches National Park
P.O. Box 907
Moab, UT 84532-0907
(435) 719–2299
www.nps.gov/arch

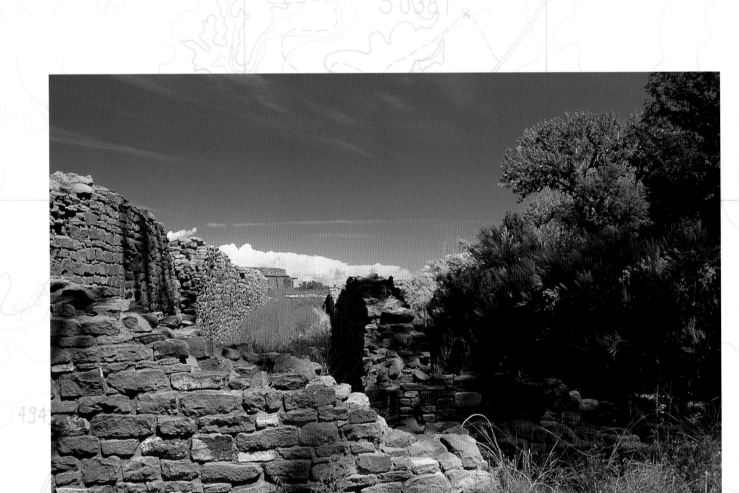

Aztec ruins

AZTEC RUINS
National Monument

LOCATION: Aztec, New Mexico

ELEVATION: 5,590 feet

NAME: A misnomer started by American settlers who mistakenly attributed the ruins to the Aztec Indians of Mexico

AREA MAP: The Aztec ruins are located just northwest of Aztec, New Mexico, near the junction of US 550 and AZ 516.

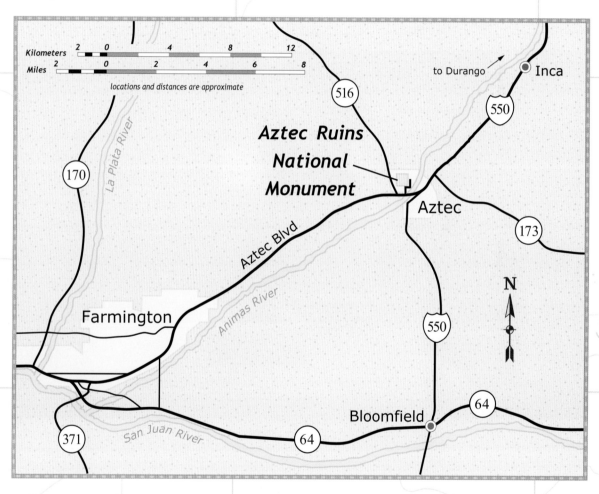

SUGGESTED LENGTH OF STAY: 3 hours

BEST TIME TO BE THERE: When the sun is high

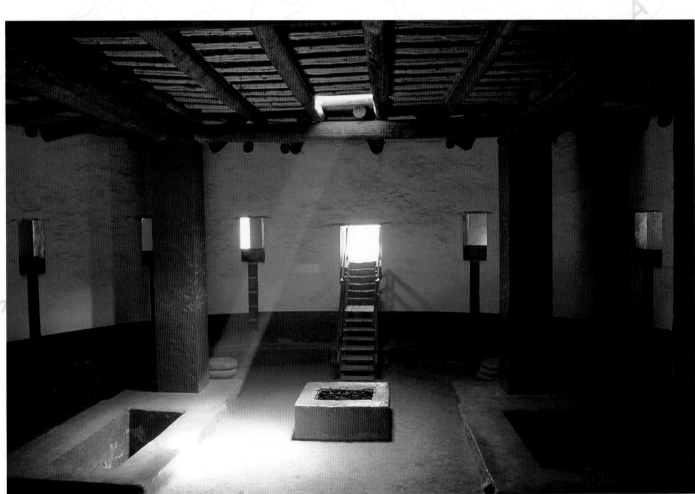

Great Kiva

AZTEC RUINS
National Monument

HIGHLIGHTS: Aztec Ruins National Monument is one of the largest and best preserved Ancestral Pueblo sites known. Archaeological evidence shows a blend of Mesa Verde and Chacoan influences, not surprising since Aztec lies midway between the two famous ruin sites of those ancient cultures.

- **West Ruin,** built in about A.D. 1115, was once an enormous three-story pueblo and is the largest in the monument, with about 400 rooms.

- **Great Kiva** is a giant circular structure of 50 feet in diameter, dropping 8 feet underground to a magnificent ceremonial chamber. Beautifully restored and maintained, this sanctuary is the only one of its kind in North America that has been so thoroughly and carefully reconstructed.

COLORFUL NOTE

On display in a small museum in the visitor center is an exceptionally fine collection of pottery and artifacts that were found when the ruins were excavated. The diverse styles uncovered occurred in two distinct layers. The lowest level yielded Chacoan pottery with hatched patterns and tapered rims. Above it, left behind at a later date, was thick-walled Mesa Verdean ware with distinct solid designs and square rims. It seems that the Chaco Anasazi were the original architects of the pueblo, but later, at about A.D. 1250, the Mesa Verde Anasazi rebuilt the pueblo and added others nearby.

GENERAL INFORMATION

FEE:	Yes	**CONVENIENCE STORE:**	No
VISITOR CENTER:	Yes	**HIKING:**	Yes
4WD NEEDED:	No	**CAMPING:**	No
GAS WITHIN 5 MILES:	Yes	**LODGING WITHIN 5 MILES:**	Yes
RESTROOMS:	Yes	**PHOTO RATING (1–5):**	2.5
FOOD/WATER:	Yes	**CHILD RATING (1–5):**	4

FOR MORE INFORMATION

Superintendent
Aztec Ruins National Monument
84 County Road 2900
Aztec, NM 87410
(505) 334–6174
www.nps.gov/azru

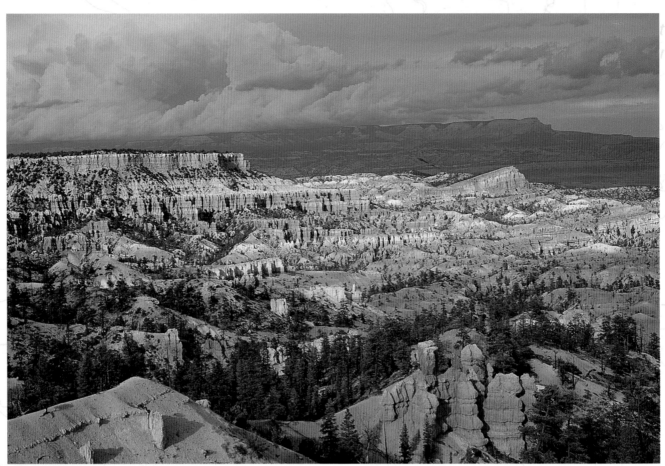

8 *Bryce Canyon*

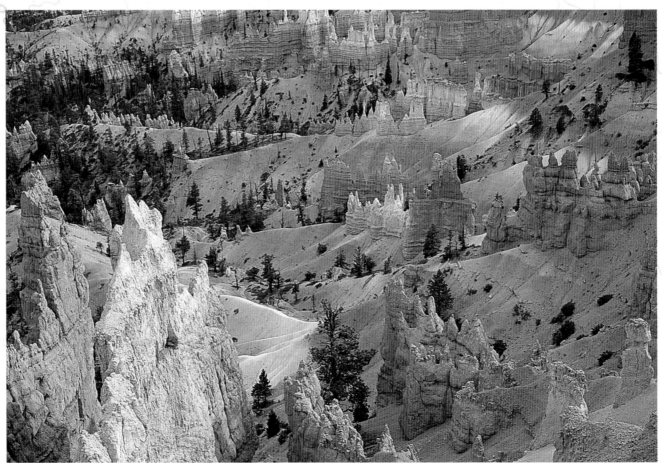

9 *Queen's Garden from Sunrise Point*

BRYCE CANYON
National Park

LOCATION: Between Panguitch and Tropic, Utah

ELEVATION: Ranges from 6,600 feet at the canyon floor to 9,105 feet on the rim at Rainbow Point

PAIUTE NAME: *Unka-timpe-Wa-Wince-Pock-ich*—"red rocks standing like men in a bowl-shaped canyon"

AREA AND LOCAL MAPS: Bryce Canyon is located 26 miles from Panguitch, Utah.

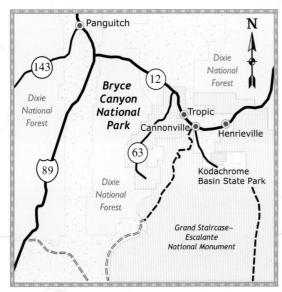

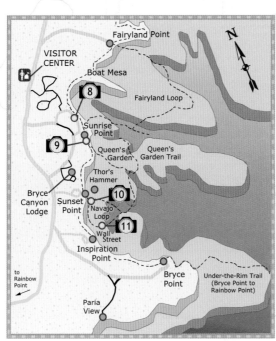

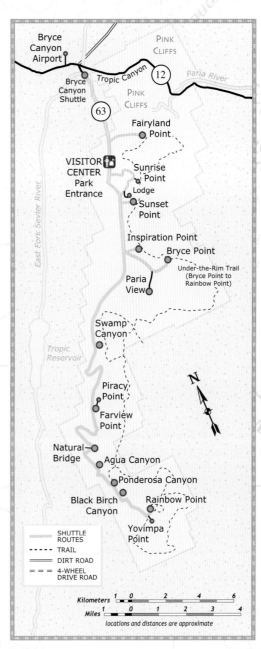

⑩ *Along Navajo Loop*

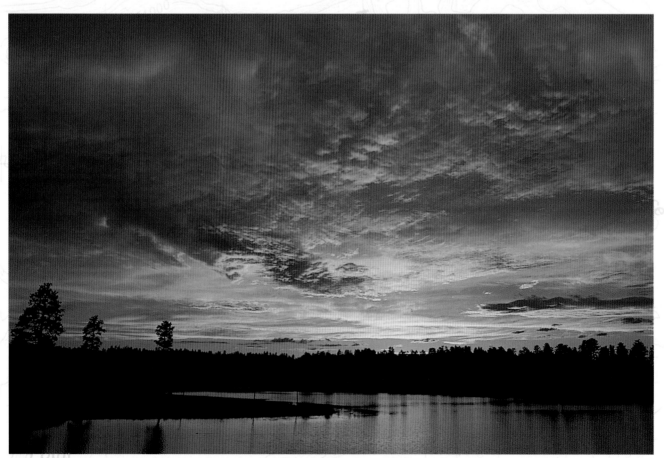

East Fork Sevier River

BRYCE CANYON
National Park

GEOLOGY: Bryce Canyon is a series of fourteen natural amphitheaters cut into the eastern edge of the Paunsaugunt Plateau by tributaries of the Paria River. From the rim, one looks down upon a vast and glorious dreamland, a colossal maze of countless brilliantly colored and tightly packed stone pinnacles called hoodoos, a variation of the Haitian word *voodoo* meaning "to cast a spell." Part of the Claron formation, they are formed by the differential chemical and physical weathering and erosion of alternating hard and soft layers of limestone, dolomite, sandstone, and shale.

The colorful and varied shading of Bryce Canyon's delicately sculpted needles and spires is due to the different oxidation states of iron (fiery tones) and manganese (cooler tints) in the rock. From pastel to intense, from rust red, burnt orange, and gold to pink, lavender, pale blue, and frosty white, the bands of color continually shift with the changing light. These unique and bizarre hoodoos have inspired such names as:

The Alligator	*The Hat Shop*	*Silent City*
Camel and Wisemen	*Hindu Temple*	*Sinking Ship*
The Cathedral	*The Organ*	*Temple of Osiris*
Chinese Wall	*Grinder's Monkey*	*Thor's Hammer*
Fairy Castle	*Queen Victoria*	*Three Wise Men*
Fairyland	*Queen's Castle*	*The Turtle*
The Gossips	*The Sentinel*	*Wall of Windows*
The Happy Family	*Shakespeare Point*	

SUGGESTED LENGTH OF STAY: 2 to 3 days

BEST TIME TO BE THERE: Summer

HIGHLIGHTS: From the bottom of the canyon to the upper edge of the high plateau, thousands of hoodoos rise up in formation like stone soldiers in an ethereal world. Rare and nearly extinct, the gnarled bristlecone pine trees keep them company on the hostile rocky slopes. The shadowy Black Mountains to the northwest and Navajo Mountain to the southeast are distant on the horizon.

Of all the overlooks along the park's 18-mile scenic drive, Sunrise, Sunset, Inspiration, and Bryce Points offer the most spectacular panoramic views. These four points look east over Bryce Amphitheater, the largest of the fourteen in the park, and are connected by the Peek-a-boo, Navajo Loop, and Queen's Garden Trails, Bryce Canyon's best and most accessible walks through the hoodoos. These trails can be hiked separately or together, as they connect under the rim between Sunrise and Sunset Points. Each hike is about 1.5 miles round trip and is moderately difficult and strenuous. Navajo Loop departs from Sunset Point, past Thor's Hammer, to a series of steep switchbacks that descend 521 feet to Wall Street, a deep, narrow gorge at the canyon floor. The bare and slender trunks of several huge Douglas fir trees rise straight up over 100 feet between the slot canyon walls. The easier Queen's Garden Trail from Sunrise Point descends 320 feet past views of Gulliver's Castle, Queen's Castle, and Queen Victoria.

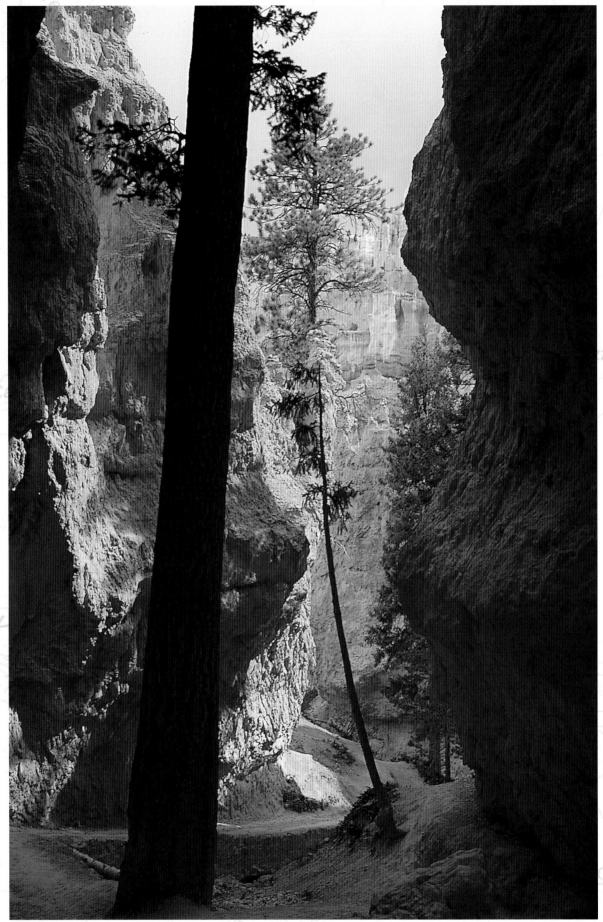

11 *Wall Street*

BRYCE CANYON
National Park

COLORFUL NOTE

Mormon settler Ebenezer Bryce (for whom the canyon was named) built a ranch at the bottom of Bryce Canyon and declared it "a hell of a place to lose a cow."

GENERAL INFORMATION

FEE:	Yes	CONVENIENCE STORE:	Yes
VISITOR CENTER:	Yes	HIKING:	Yes
4WD NEEDED:	No	CAMPING:	Yes
GAS WITHIN 5 MILES:	Yes	LODGING WITHIN 5 MILES:	Yes
RESTROOMS:	Yes	PHOTO RATING (1–5):	5
FOOD/WATER:	Yes	CHILD RATING (1–5):	5

CAUTION: The maze of steep, twisting trails that lead down to the canyon floor may not be suitable for young children. Hike with caution at this altitude.

FOR MORE INFORMATION

Superintendent
Bryce Canyon National Park
P.O. Box 170001
Bryce Canyon, UT 84717-0001
(435) 834–5322
www.nps.gov/brca

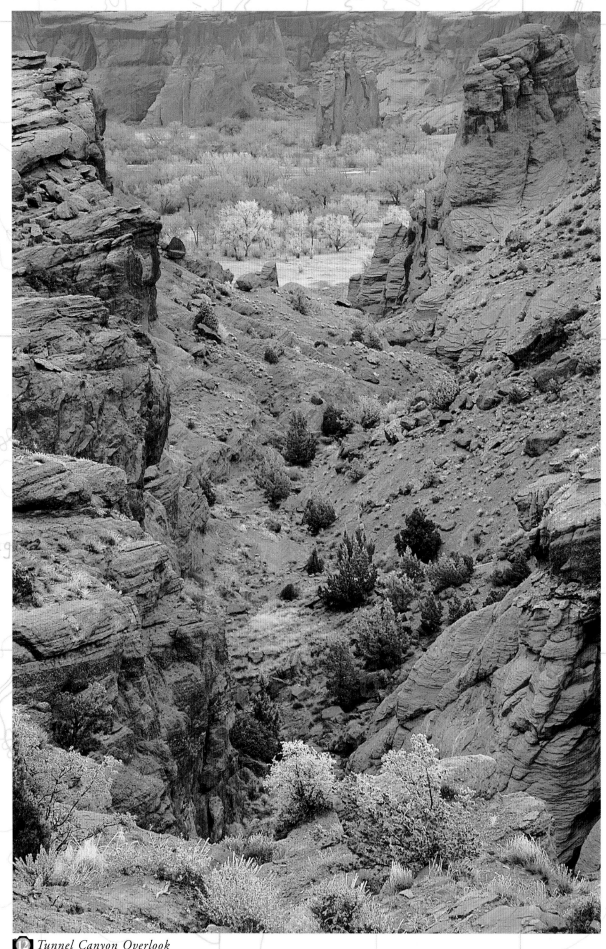

12 *Tunnel Canyon Overlook*

CANYON DE CHELLY
National Monument

LOCATION: Chinle, Arizona, within the Navajo (Dineh) Nation

ELEVATION: Ranges from about 5,500 feet at the mouth of the canyon to about 7,000 feet at its eastern end

NAVAJO NAME: *Tsegi*—"rock canyon" (de Chelly is the corrupted pronunciation of the Navajo word *Tsegi* by the early-nineteenth-century Spanish explorers and American settlers new to the area)

AREA MAP: Canyon de Chelly is located 3 miles east of Chinle, Arizona.

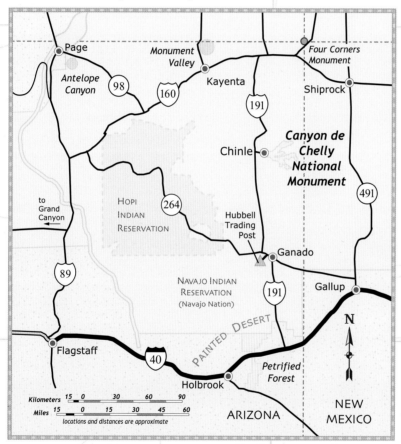

GEOLOGY: On the eastern edge of the Great Basin Desert lies Canyon de Chelly National Monument, a spectacular forked gash created by two deep canyons, Canyon de Chelly (26 miles long) and Canyon del Muerto (25 miles long). As if the earth had been sliced open, the ruddy de Chelly sandstone walls rise up sheer and smooth, striped with long, dark mineral streaks called desert varnish. One thousand feet below the rim on Defiance Plateau lies an oasis, a lush valley of farmland and trees supported by Rio de Chelly, which flows along the pink sandy bottom of the canyon. The exquisite beauty of Canyon de Chelly is in the gentle loveliness of its textured forms, graceful on an intimate scale.

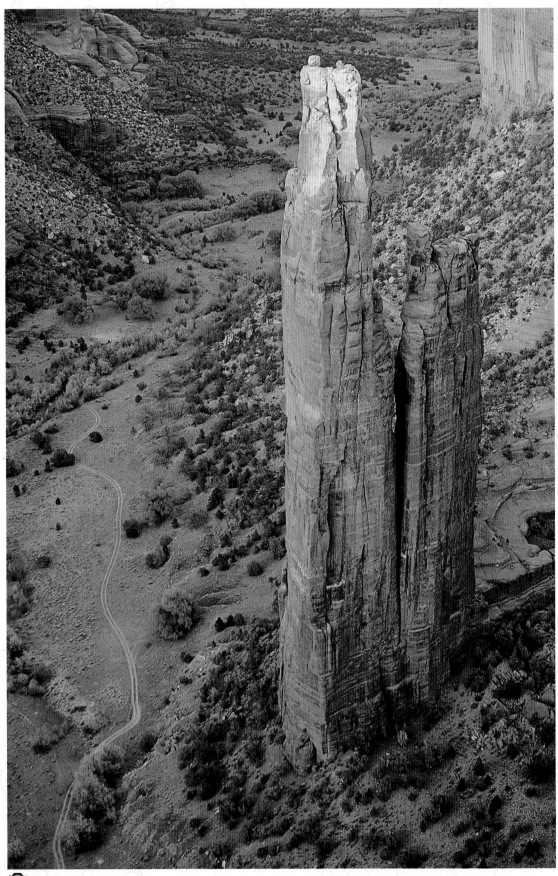

13 *Spider Rock*

CANYON DE CHELLY
National Monument

LOCAL MAP

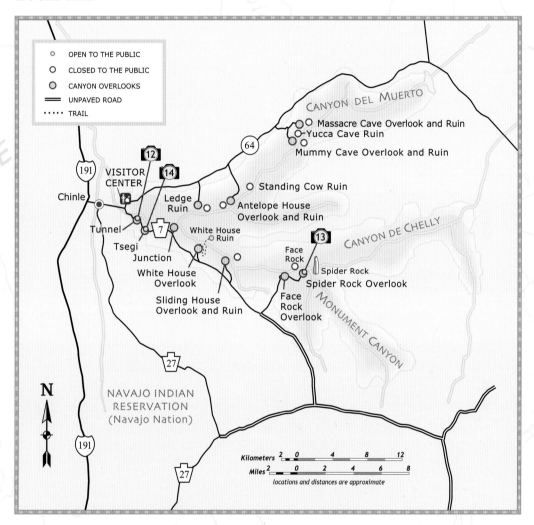

SUGGESTED LENGTH OF STAY: 1 to 2 days

BEST TIME TO BE THERE: Afternoon

HIGHLIGHTS:

- **Spider Rock** (*Na'Tseashje'ii*) is a 230 million-year-old sandstone needle shooting up 800 feet from the canyon floor. At the top is the legendary home of the deity Spider Woman (*Na'Tseasheje'ii Asdzaa*), who is believed to have taught the Navajo the art of weaving.

- **The White House Ruin,** a two-tiered cliff dwelling, was once home to almost one-hundred people in the years A.D. 1060 to 1275. A 2.5-mile round-trip trail makes a 600-foot descent from the rim to the canyon floor and the ruins, which are built within a cavern that lies beneath a heavily varnished south-facing canyon wall.

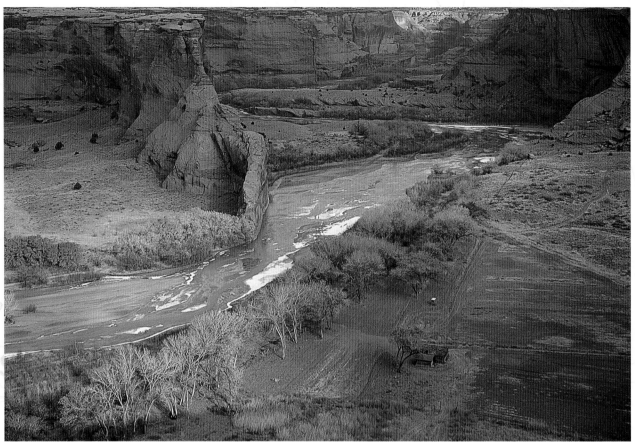

14 *Tsegi Overlook*

Hubbell Trading Post

CANYON DE CHELLY
National Monument

COLORFUL NOTES

In 1805, within Canyon del Muerto (Canyon of the Dead), Spanish soldiers slaughtered 115 Navajos who had retreated into what was later named Massacre Cave. In 1849, ancient burial remains were found in Mummy Cave, a ruin site of fifty rooms.

If you are approaching Canyon de Chelly from the south, don't miss Hubbell Trading Post National Historic Site in Ganado, Arizona, about 40 miles south of Chinle, near the junction of US 191S and AZ 264E. Founded in the late 1800s by Don Lorenzo Hubbell, this colorful trading post continues to offer a staggering selection of world-class Native American rugs, pottery, jewelry, and other arts and crafts. Hubbell was a great friend to the Navajo, helping them after they returned from their Long Walk by serving as peacemaker, translator, interpreter, and supporter of their art and trade. The Navajo fondly called him "Old Mexican," and when he died in 1930, he was buried atop a hill overlooking his famous trading post.

GENERAL INFORMATION

FEE:	No	CONVENIENCE STORE:	Yes
VISITOR CENTER:	Yes	HIKING:	Yes
4WD NEEDED:	No	CAMPING:	Yes
GAS WITHIN 5 MILES:	Yes	LODGING WITHIN 5 MILES:	Yes
RESTROOMS:	Yes	PHOTO RATING (1–5):	4
FOOD/WATER:	Yes	CHILD RATING (1–5):	2.5

NOTE: With the exception of the White House Ruin trail, all hiking and off-road driving in Canyon de Chelly requires an authorized Navajo guide. Do not photograph Native Americans, their homes, or possessions without permission. It is customary to offer a gratuity for this privilege.

FOR MORE INFORMATION

Superintendent
Canyon de Chelly National Monument
P.O. Box 588
Chinle, AZ 86503
(928) 674–5500
www.nps.gov/cach

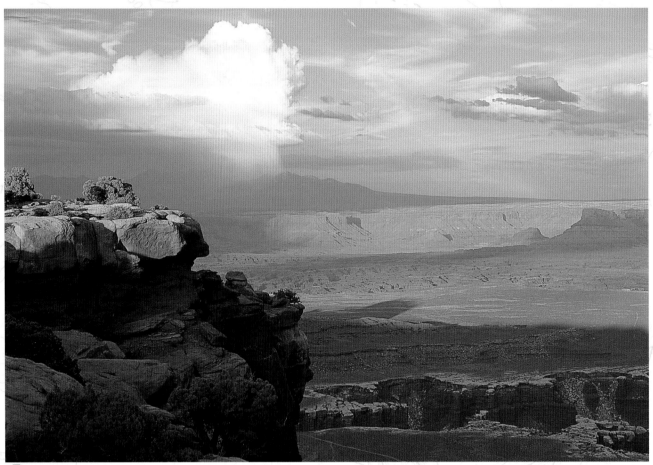

15 *Looking east from Grand View Point*

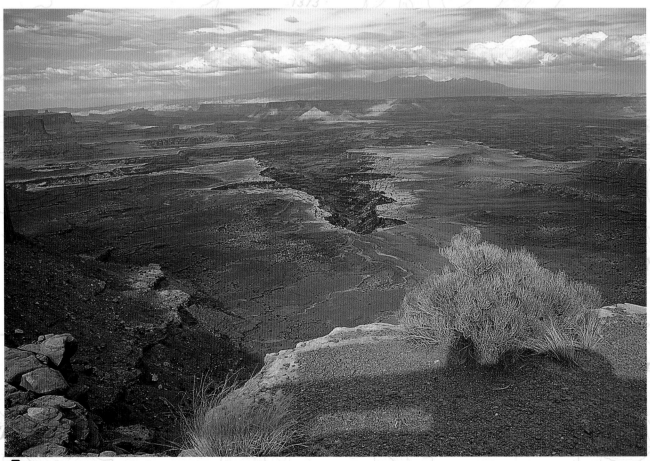

16 *Buck Canyon Overlook*

CANYONLANDS
National Park

LOCATION: Southeastern Utah

ELEVATION: Ranges from 3,720 feet at Cataract Canyon to 6,987 feet on Cedar Mesa in the Needles District

AREA MAP: Canyonlands National Park is divided into three districts by the confluence of the Green and Colorado Rivers, each district having a separate and isolated access.

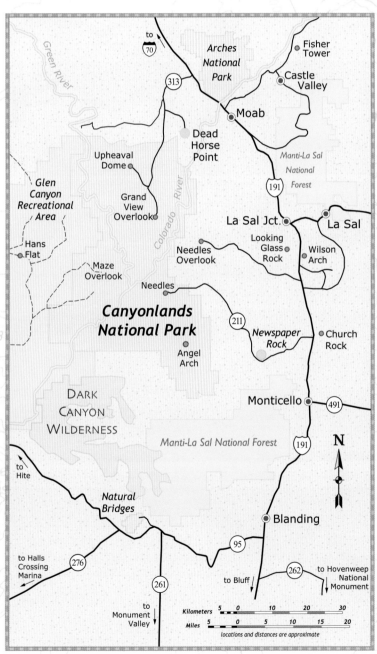

- **Island in the Sky District:** From Moab, drive 9 miles north on US 191, then 26 miles southwest on UT 313.

- **Needles District:** From Moab, drive 41 miles south on US 191, then 34 miles west on UT 211.

- **Maze District:** Located 46 miles east of the UT 24 turnoff to the Hans Flat Ranger Station. This area is for four-wheel-drive vehicles only.

Sedimentary rock

LOCAL MAP

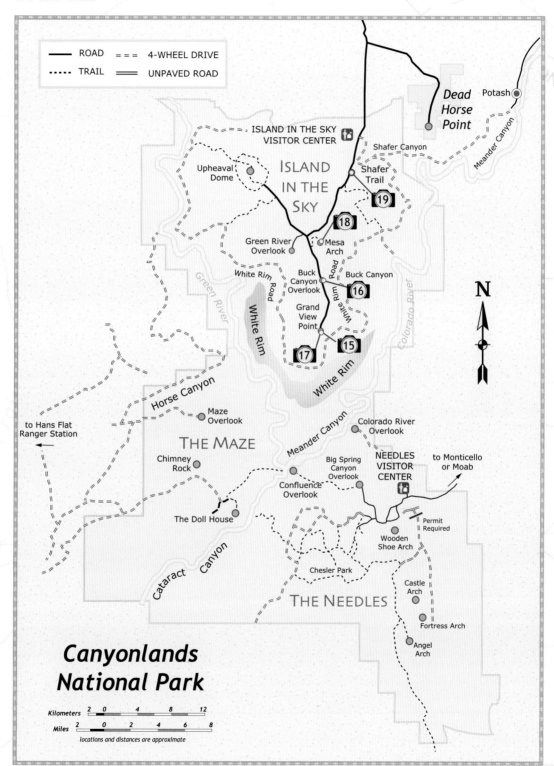

ROAD === 4-WHEEL DRIVE
TRAIL === UNPAVED ROAD

Dead Horse Point

Potash

ISLAND IN THE SKY VISITOR CENTER

Shafer Canyon

Meander Canyon

ISLAND IN THE SKY

Upheaval Dome

Shafer Trail

19

18

Green River Overlook

Mesa Arch

White Rim Road

Buck Canyon

Buck Canyon Overlook

16

Grand View Point

15

17

White Rim

White Rim

Colorado River

N

Horse Canyon

Maze Overlook

Colorado River Overlook

to Hans Flat Ranger Station

THE MAZE

Meander Canyon

Chimney Rock

Big Spring Canyon Overlook

NEEDLES VISITOR CENTER

to Monticello or Moab

Confluence Overlook

The Doll House

Permit Required

Wooden Shoe Arch

Cataract Canyon

Chesler Park

Castle Arch

THE NEEDLES

Fortress Arch

Angel Arch

Canyonlands National Park

Kilometers 2 0 4 8 12
Miles 2 0 2 4 6 8

locations and distances are approximate

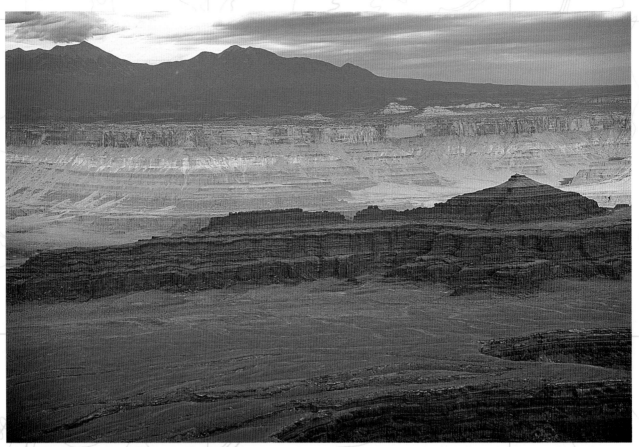

The La Sal Mountains and Meander Canyon

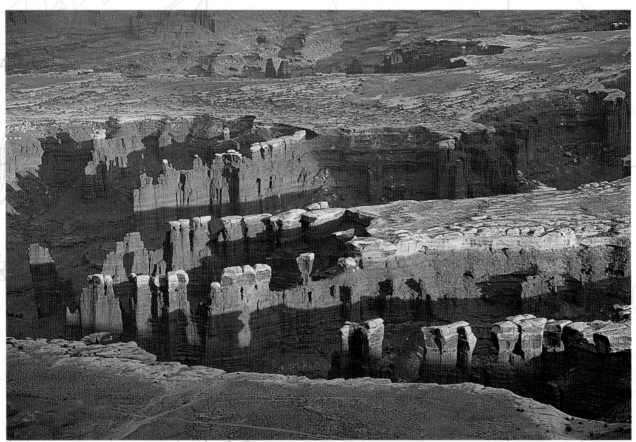

White Rim and the Standing Up Rocks from Grand View Point

GEOLOGY: At the heart of the Colorado Plateau lies Canyonlands National Park, a labyrinth of stone so rugged and unforgiving that in all of its 527 square miles there are fewer than 30 miles of paved roads.

The highest and northernmost district of the park is a vast mesa called Island in the Sky, with Grand View Point at the southern tip. At a drop of 1,250 feet from the mesa's edge is the White Rim, the flat top of an almost continuous escarpment of pale sandstone roughly following its contour. Another 1,000 feet below, the Green River from the west and the Colorado River from the east flow slowly toward their confluence. But once united, their combined power rages through a 14-mile stretch of white water in Cataract Canyon, dropping 30 feet in 1 mile.

Most diverse in its landscape, the Needles District to the southeast is named for the immense red (Cutler formation) and white (Cedar Mesa sandstone) spires that shoot up 300 feet in tangled clusters from the desert grassland of Chesler Park. Hidden in the canyons of the backcountry are numerous arches of great variety, enormous potholes, and grassy valleys between steep, sheer walls of fractured rock. Amazingly, ancient Puebloans and Fremont civilizations once survived here, leaving their trace in petroglyphs and well-preserved ruin sites such as Tower Ruin near Horse Canyon and Square Tower in Hovenweep National Monument.

To the west, the Maze remains a remote and inaccessible wilderness requiring a rocky descent of 1,000 feet from the Orange Cliffs to the park entrance in Elaterite Basin. Only one primitive trail penetrates this jumbled confusion of sheer-edged mesas and deep, twisting canyons cut by the ceaseless chiseling action of water, gravity, and ice.

SUGGESTED LENGTH OF STAY: 2 to 3 days

BEST TIME TO BE THERE: Late spring

HIGHLIGHTS:

- **Grand View Point:** From this southern tip of Island in the Sky Mesa, the view opens out for 100 miles over Monument Basin. On the horizon rest the violet cones of the La Sal, Abajo, and Henry Mountain Ranges. North and South Sixshooter Peaks, twin buttes with tops of Wingate sandstone, as well as Cathedral Butte are visible in the network of canyons, fins, and spires below. At 305 feet, the Totem Pole is the most prominent of the many Standing Up Rocks, deep brown Cutler formation pinnacles with White Rim sandstone tips.

- **Sunrise at Mesa Arch:** 2,100 feet above the Colorado River on the rim of Island in the Sky Mesa, this handsome span frames Washer Woman Arch, Airport Tower, and the La Sal Mountains 35 miles to the east. The half-mile round-trip trail to Mesa Arch can be confusing in low light, so follow the rock cairns carefully.

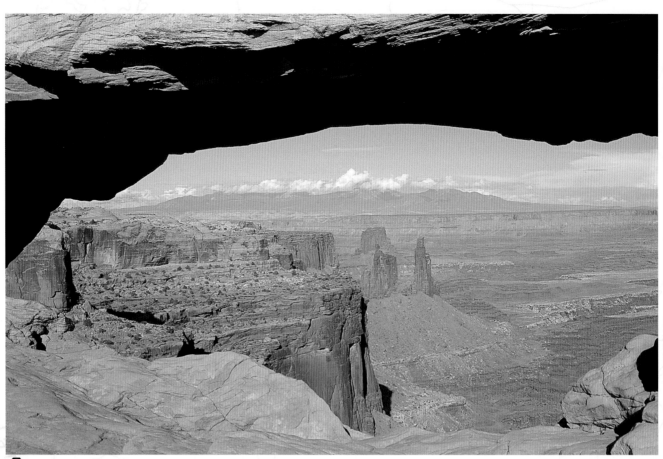

18 *Overlook at Mesa Arch*

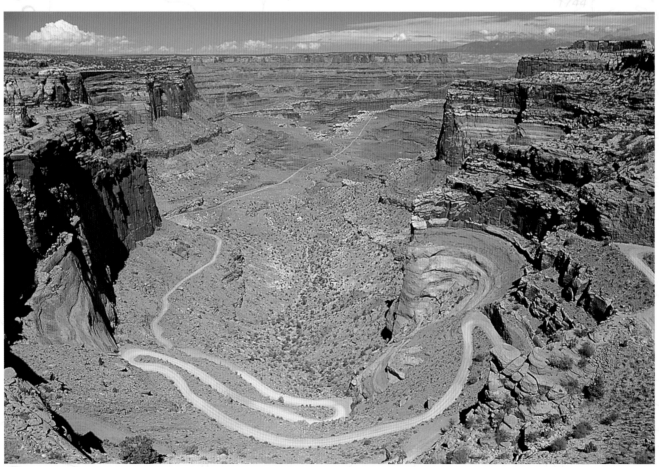

19 *Shafer Trail*

COLORFUL NOTE

The remote areas around Canyonlands National Park were once a hideout for outlaws Butch Cassidy and the Sundance Kid.

GENERAL INFORMATION

FEE:	Yes	CONVENIENCE STORE:	No
VISITOR CENTER:	Yes	HIKING:	Yes
4WD NEEDED:	No*	CAMPING:	Yes
GAS WITHIN 5 MILES:	No	LODGING WITHIN 5 MILES:	No
RESTROOMS:	Yes	PHOTO RATING (1–5):	4.5
FOOD/WATER:	No	CHILD RATING (1–5):	1

*CAUTION: Four-wheel-drive vehicles are essential for travel off the main road in the Maze and Needles Districts, where the terrain is so severe that a 1-mile stretch can take two hours to drive. Services and water supply may be nonexistent in these remote and undeveloped areas of the park. Protect fragile cryptobiotic soil crust by walking only on hard rock or marked trails.

FOR MORE INFORMATION

Superintendent
Canyonlands National Park
2282 South West Resource Boulevard
Moab, UT 84532
(435) 719–2313
www.nps.gov/cany

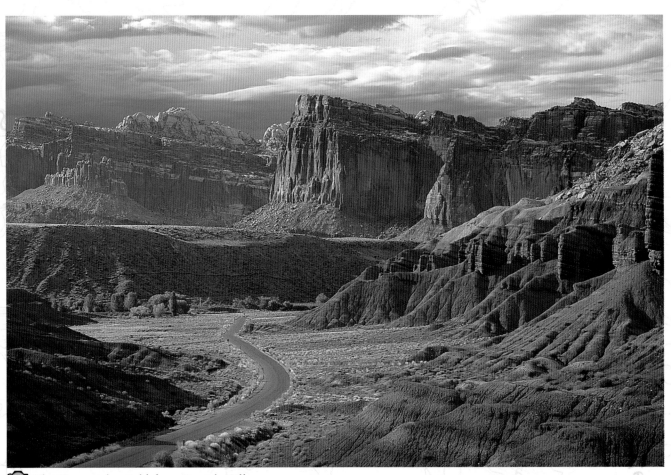

20 *The Waterpocket Fold from Danish Hill*

CAPITOL REEF
National Park

LOCATION: Near Torrey, Utah

ELEVATION: Ranges from 3,967 feet in Halls Creek to 8,960 feet near Thousand Lake Mountain

LEGENDARY NAME: "Land of the sleeping rainbow"

AREA MAP: The entrance to Capitol Reef National Park is located 5 miles east of Torrey, Utah, on UT 24.

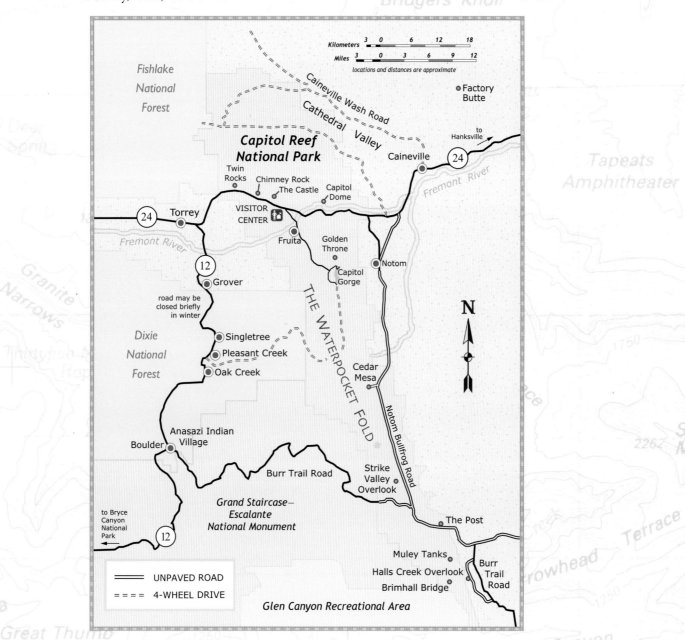

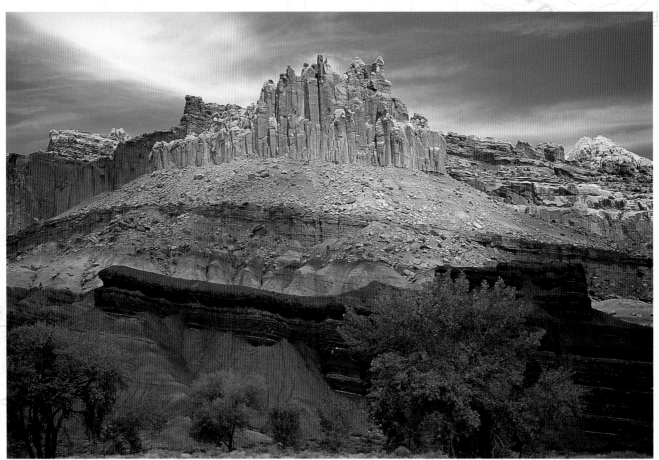

21 *The Castle*

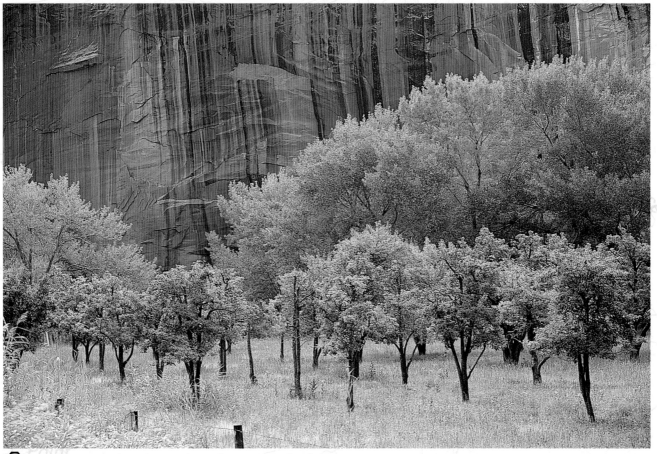

22 *Desert-varnished sandstone above the Fruita orchard*

CAPITOL REEF
National Park

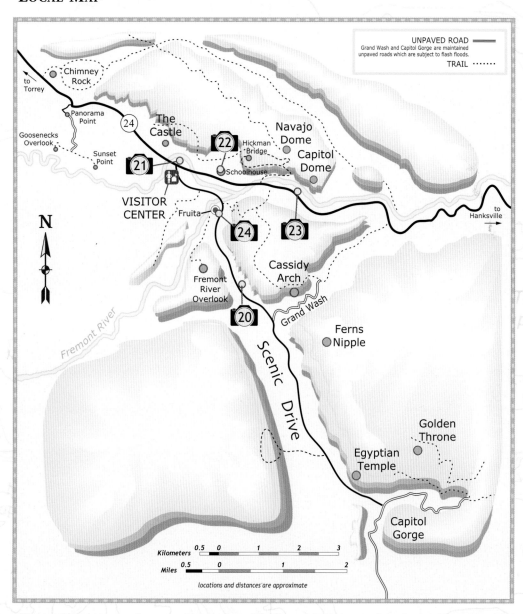

UNPAVED ROAD ═══
Grand Wash and Capitol Gorge are maintained
unpaved roads which are subject to flash floods.
TRAIL ·········

Little Saddle

BOUNDARY

Chimney Rock

to Torrey

Panorama Point

Goosenecks Overlook

The Castle

24

22

Hickman Bridge

Navajo Dome

Capitol Dome

Sunset Point

21

Schoolhouse

VISITOR CENTER

Fruita

24

23

to Hanksville

Cassidy Arch

Fremont River Overlook

20

Grand Wash

Ferns Nipple

Fremont River

Scenic Drive

Golden Throne

Egyptian Temple

Capitol Gorge

Kilometers 0.5 0 1 2 3
Miles 0.5 0 1 2

locations and distances are approximate

N

Granite Narrows

Great Thumb Point

Mesa

Tapeats Amphitheater

Arrowhead Terrace

Galloway Canyon

2262 Mt

GEOLOGY: Vast and remote, Capitol Reef National Park lies within the Waterpocket Fold, an immense fractured wrinkle in the earth's crust extending for 100 miles from Thousand Lake Mountain to Lake Powell. Tremendous buckling forces have exposed a tilted one-sided ridge (monocline), a long, broad line of rising cliffs that ripple in 1,500-foot sandstone waves, comprising the rugged and rocky wilderness, twisting canyons, and slickrock expanses in this forbidding and beautiful park.

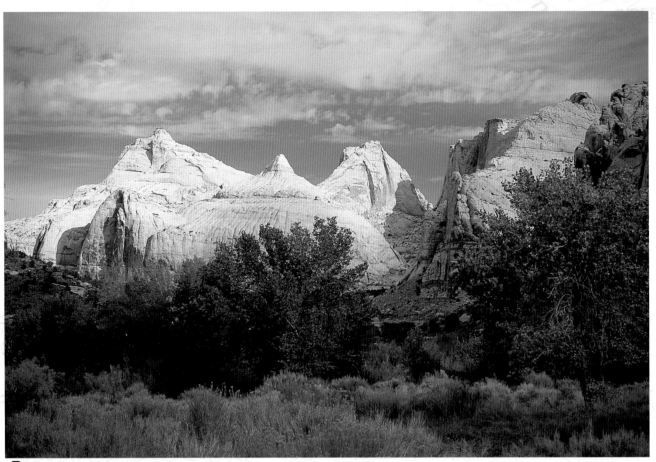

23 *Navajo Dome*

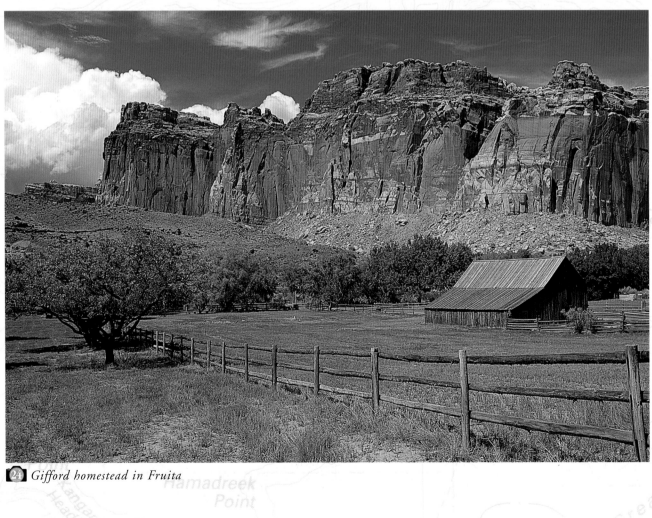

24 *Gifford homestead in Fruita*

SUGGESTED LENGTH OF STAY: 2 to 3 days

BEST TIME TO BE THERE: Spring, when the wildflowers are in bloom, or fall during the fruit harvest

HIGHLIGHTS: The extraordinary variety of landforms:

- 1,000-foot red and white tiered sandstone ridges
- sheer canyon walls, desert-varnished with iron and manganese oxides
- jumbled red rock, petrified sand dunes, and massive domes
- colorful cliffs, buttes, terraces, spires, and arches
- eroded basins or "pockets" filled with rainwater
- the lush Fremont River Valley filled with tamarisk, cottonwood, willow, and box elder
- ancient pictographs and petroglyphs of the Fremont culture
- farms, pastures, and orchards in the frontier Mormon settlement of Fruita

COLORFUL NOTE

Capitol Reef National Park was named after the formidable rock domes of white Navajo sandstone that reminded early settlers of the U.S. Capitol and was a barrier to travel until 1871.

GENERAL INFORMATION

FEE:	Yes	**CONVENIENCE STORE:**	No
VISITOR CENTER:	Yes	**HIKING:**	Yes
4WD NEEDED:	No	**CAMPING:**	Yes
GAS WITHIN 5 MILES:	Yes	**LODGING WITHIN 5 MILES:**	Yes
RESTROOMS:	Yes	**PHOTO RATING (1–5):**	4
FOOD/WATER:	No	**CHILD RATING (1–5):**	2.5

FOR MORE INFORMATION

Superintendent
Capitol Reef National Park
HC 70 Box 15
Torrey, UT 84775–9602
 (435) 425–3791
www.nps.gov/care

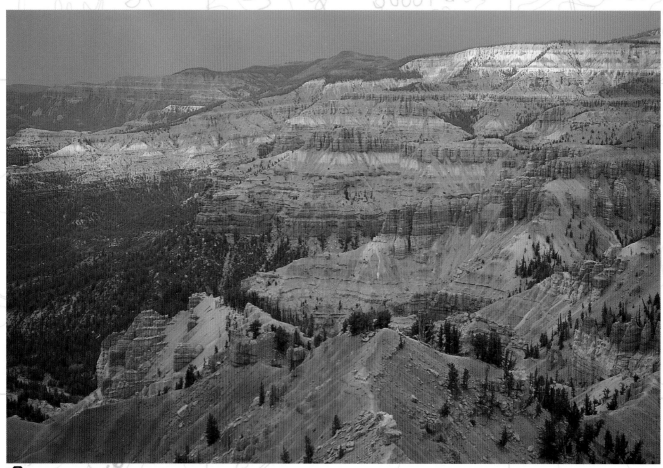

25 *Cedar Breaks National Monument from Chessman Ridge*

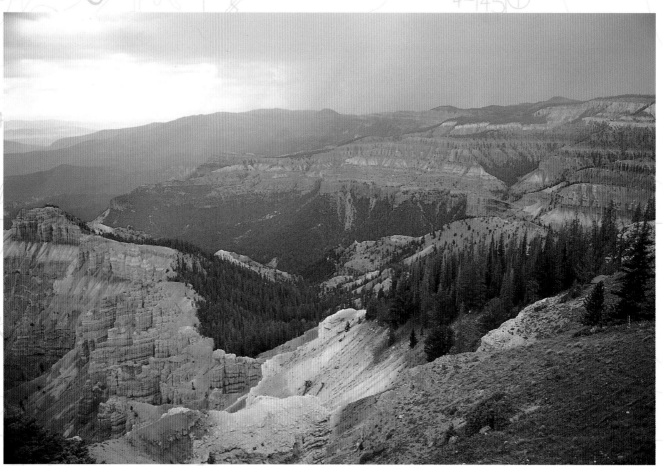

26 *From Point Supreme*

CEDAR BREAKS
National Monument

LOCATION: Southwestern corner of Utah

ELEVATION: Ranges from 8,100 feet at the canyon floor to 10,467 feet on the rim at Chessman Ridge Overlook

NAME: For the forests of cedar (actually juniper) trees and breaks (badlands)

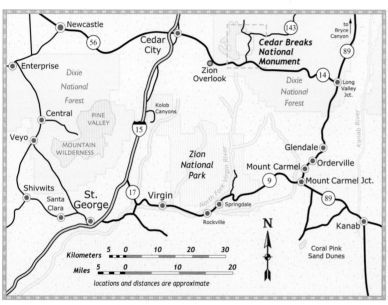

AREA AND LOCAL MAPS: Cedar Breaks National Monument is located off UT 14, about 23 miles east of Cedar City, Utah.

GEOLOGY: Intensely colorful Cedar Breaks is a huge natural limestone amphitheater cut into the Pink Cliffs that define the steep western edge of the Markagunt Plateau, the same plateau from which nearby Zion Canyon is carved. The geography and appearance are similar to those of Bryce Canyon; from the forested rim of a high plateau, eroded slopes fall away sharply in ragged folds filled with thousands of Claron formation spires brilliantly colored by the different oxidation states of iron (rust red, bright orange, and golden yellow tones) and manganese (purple, pink, and lavender tints) in the rock. But unlike Bryce Canyon, which is a series of smaller amphitheaters, Cedar Breaks is a "Circle of Painted Cliffs," a single enormous bowl more than 3 miles in diameter and almost 2,500 feet deep.

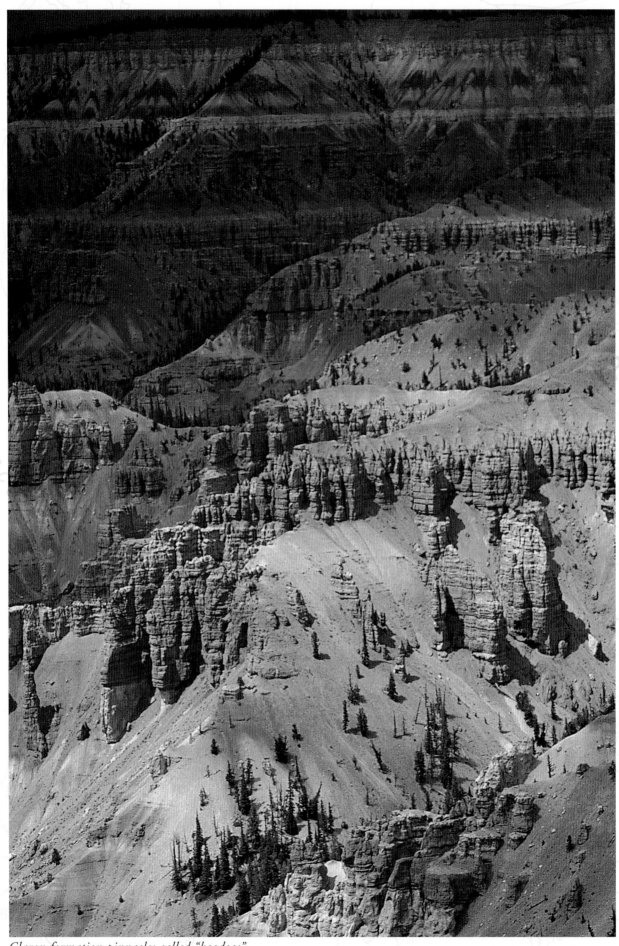

Claron formation pinnacles called "hoodoos"

SUGGESTED LENGTH OF STAY: 1 day

BEST TIME TO BE THERE: Summer, from late June to early August when magnificent carpets of wildflowers are in perpetual bloom

HIGHLIGHTS:

• Easy and self-guiding Alpine Pond Trail makes a 2-mile loop from Chessman Ridge Overlook to spring-fed Alpine Pond on Upper Rattle Creek.

• More scenic but more difficult Ramparts Trail (4 miles, round trip) follows the plateau rim, dropping 600 feet from the visitor center past Point Supreme (10,350 feet) and Spectra Point (10,285 feet) to the edge at Ramparts Overlook (9,952 feet) above Crescent Hollow.

COLORFUL NOTE

At Spectra Point, a lone bristlecone pine, gnarled and weatherbeaten, has survived for more than 1,600 years. These ancient trees are native to the Cedar Breaks high country, where winds are fierce and the soil is thin and dry.

GENERAL INFORMATION

FEE:	Yes	**CONVENIENCE STORE:**	No
VISITOR CENTER:	Yes	**HIKING:**	Yes
4WD NEEDED:	No	**CAMPING:**	Yes
GAS WITHIN 5 MILES:	No	**LODGING WITHIN 5 MILES:**	No
RESTROOMS:	Yes	**PHOTO RATING (1–5):**	4
FOOD/WATER:	No	**CHILD RATING (1–5):**	2

CAUTION: Roads and services in Cedar Breaks National Monument are closed from mid-October through May because of the typically heavy snowfall at this elevation.

FOR MORE INFORMATION

Cedar Breaks National Monument
2390 West Highway 56, Suite 11
Cedar City, UT 84720-4151
(435) 586–9451
www.nps.gov/cebr

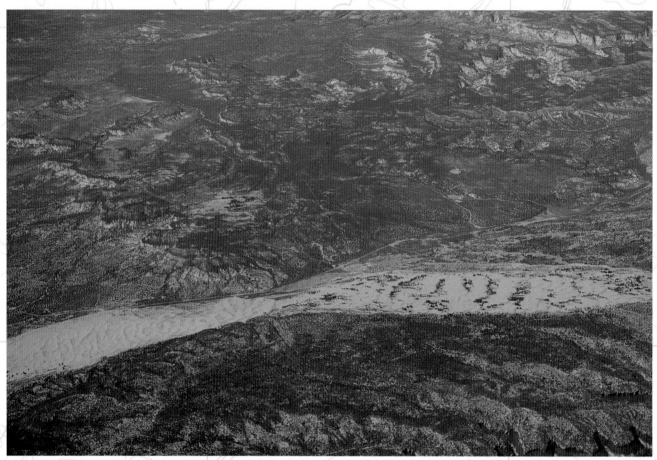

Coral Pink Sand Dunes from 35,000 feet

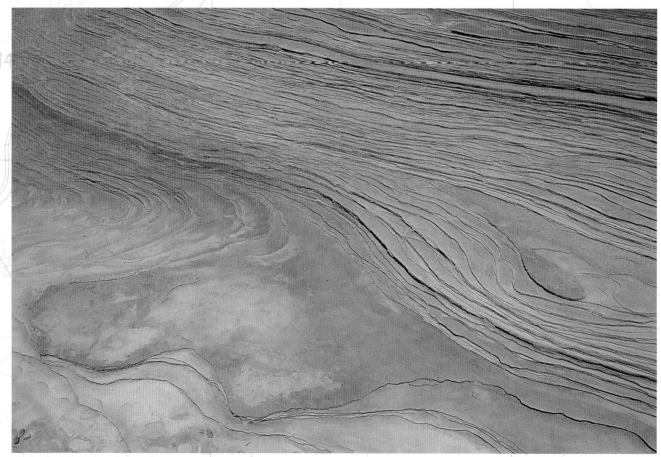

Cross-bedded Navajo sandstone

CORAL PINK
SAND DUNES
State Park

LOCATION: Southwestern Utah, near Kanab

ELEVATION: 6,000 feet

AREA MAP: From Kanab, drive north about 8 miles on US 89 to between Mile Markers 72 and 73, turn left (west), and drive 9.3 miles on Hancock Road to its end, then turn left (south), and drive 1 mile to the park. From Mount Carmel Junction, drive south for 3.5 miles on US 89, then turn right (south) and drive 11 miles to the park.

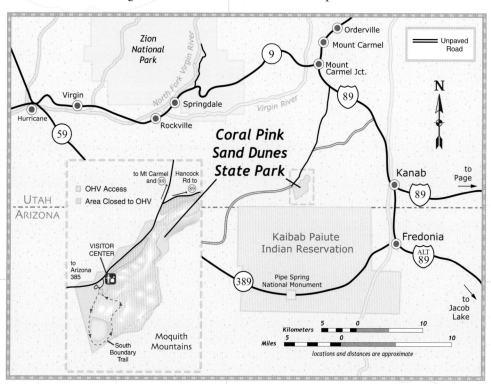

GEOLOGY: Established in 1963 with land acquired from the Bureau of Land Management, Coral Pink Sand Dunes State Park encompasses 3,730 acres of rocky expanse in southwestern Utah just southeast of Zion National Park. Here, steep cliffs and canyon walls of red Navajo sandstone studded with windworn juniper and piñon surround and give way to a stunning coral-colored dunefield, an enormous streak of sand and flowers in the middle of nowhere. This scene of stark and unlikely contrast is explained by the Venturi effect: A small notch between the Moquith and Moccasin Mountains acts like a funnel and has accelerated the prevailing winds rising from hot lower elevations with force enough to carry grains of eroded Navajo sandstone to the lofty dune heights of several hundred feet.

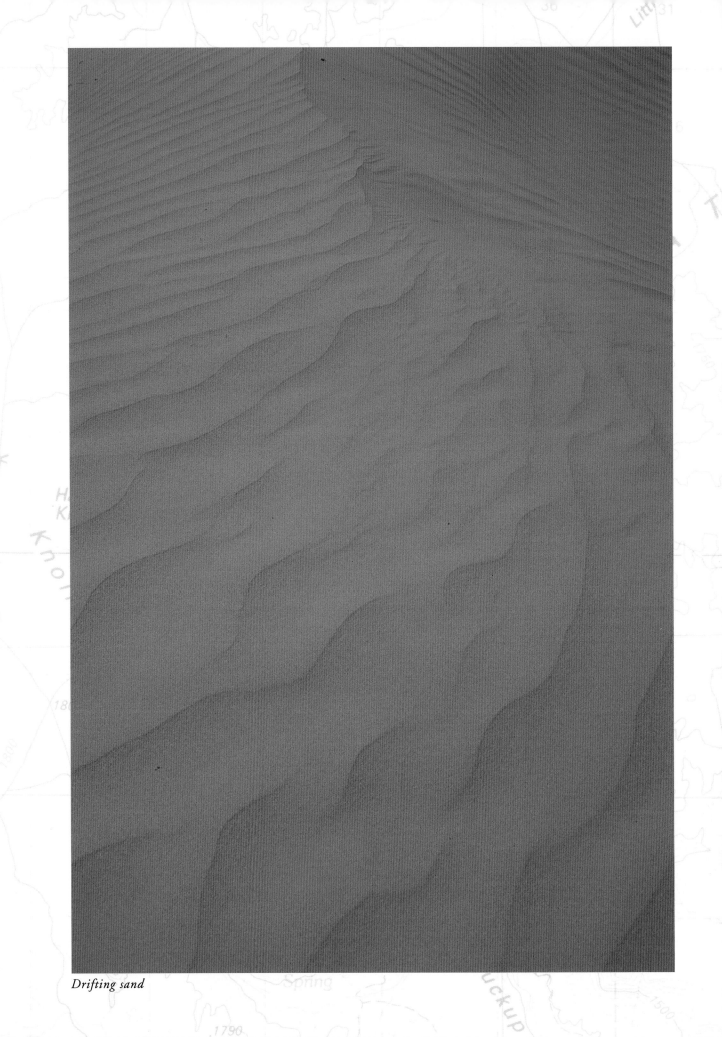

Drifting sand

CORAL PINK SAND DUNES
State Park

SUGGESTED LENGTH OF STAY: 4 hours

BEST TIME TO BE THERE: June and September, at sunrise and sunset

HIGHLIGHTS: While there are no developed hiking trails within the park, several lie adjacent and are easily accessible, including the following:

- **Harris Mountain,** north of the park, offers views of the sand dunes and Zion National Park.
- **Moquith Mountains** define the east boundary of the park where views of Kanab Canyon and the Grand Canyon's North Rim can be seen from atop the dunes.
- **South Fork Indian Canyon Pictographs** trailhead is located 4 miles northeast of the park.

COLORFUL NOTE

The sprawling dunes and crystalline blue skies at Coral Pink Sand Dunes State Park so closely resemble Egypt that the park was used as a shot location for the movie *The Greatest Story Ever Told* (1965).

GENERAL INFORMATION

FEE:	Yes	CONVENIENCE STORE:	No
VISITOR CENTER:	No	HIKING:	Yes
4WD NEEDED:	No	CAMPING:	Yes
GAS WITHIN 5 MILES:	No	LODGING WITHIN 5 MILES:	No
RESTROOMS:	Yes	PHOTO RATING (1–5):	3
FOOD/WATER:	No	CHILD RATING (1–5):	4

NOTE: Off-road vehicles are permitted on the dunes, but strict regulations apply, and riders should be well informed before venturing out. Paddle-type tires work best on the soft sand, and park regulations ask drivers to attach an 8-foot whip with a flag to their vehicles.

FOR MORE INFORMATION

Coral Pink Sand Dunes State Park
P.O. Box 95
Kanab, UT 84741-0095
(435) 648–2800
www.stateparks.utah.gov

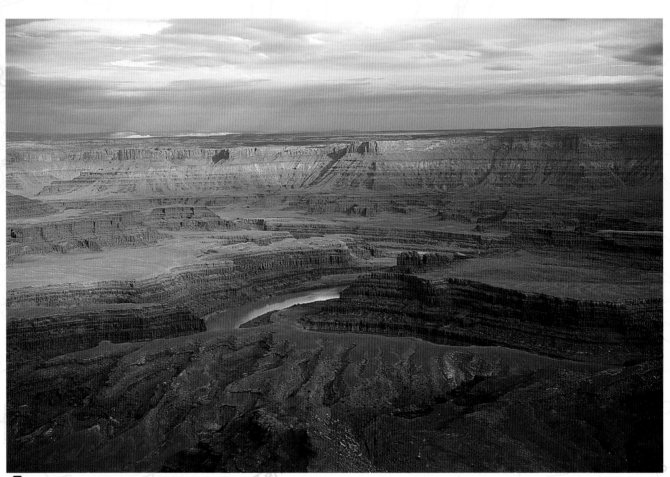

Colorado River from Dead Horse Point

DEAD HORSE POINT
State Park

LOCATION: Near Moab, Utah, on Island in the Sky Mesa

ELEVATION: 6,000 feet

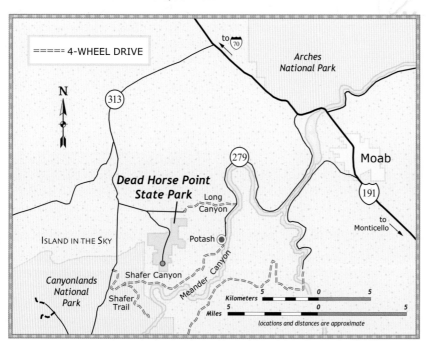

AREA MAP:
From Moab, drive 9 miles north on US 191, then 22 miles west on UT 313 to the park turnoff.

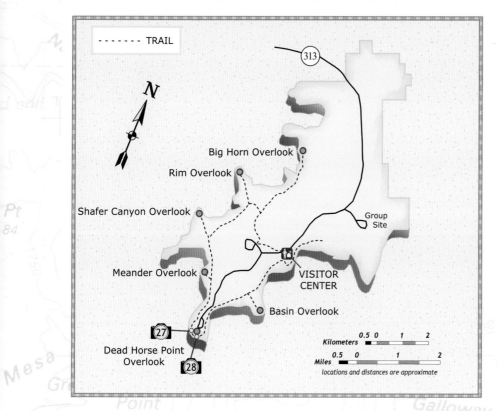

LOCAL MAP

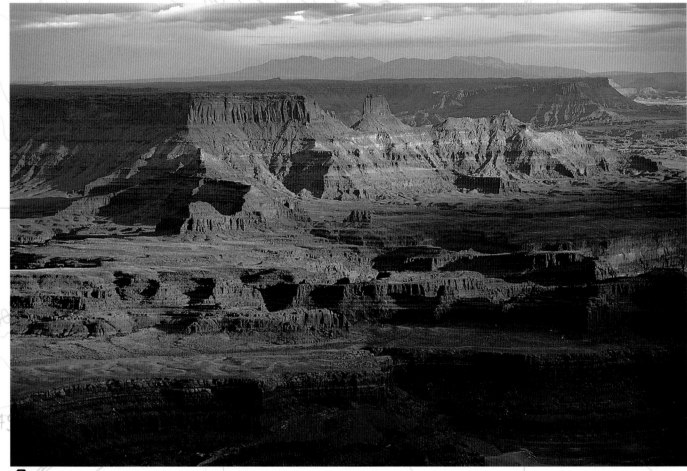

28 *Meander Canyon*

DEAD HORSE POINT
State Park

GEOLOGY: Dead Horse Point on Island in the Sky Mesa is a promontory overlooking Meander Canyon and a spectacular panorama of rock strata, pinnacles, buttes, and cliffs carved into layers of sandstone by the Colorado River 2,000 feet below.

SUGGESTED LENGTH OF STAY: 4 to 6 hours

BEST TIME TO BE THERE: Late afternoon to sunset

HIGHLIGHTS: The view from the point is a stunning one of Meander Canyon, outstretched in a maze of ragged cliffs that peel away, layer after layer, like staircases of stone in heavenly shades of red, pink, lavender, and gray. Meander Canyon is more intimate than the Grand Canyon, and perhaps more beautiful in the richness of its hues and the elegance of its proportions.

COLORFUL NOTE

The name Dead Horse Point comes from a local legend that tells of a band of wild mustangs that were accidentally stranded and left to die out on the mesa.

GENERAL INFORMATION

FEE:	Yes	**CONVENIENCE STORE:**	No
VISITOR CENTER:	Yes	**HIKING:**	Yes
4WD NEEDED:	No	**CAMPING:**	Yes
GAS WITHIN 5 MILES:	No	**LODGING WITHIN 5 MILES:**	No
RESTROOMS:	Yes	**PHOTO RATING (1–5):**	4.5
FOOD/WATER:	No	**CHILD RATING (1–5):**	1

CAUTION: Most rim overlooks are without railings and are unsafe for young children.

FOR MORE INFORMATION

Dead Horse Point State Park
P.O. Box 609
Moab, UT 84532-0609
(435) 259–2614
www.stateparks.utah.gov

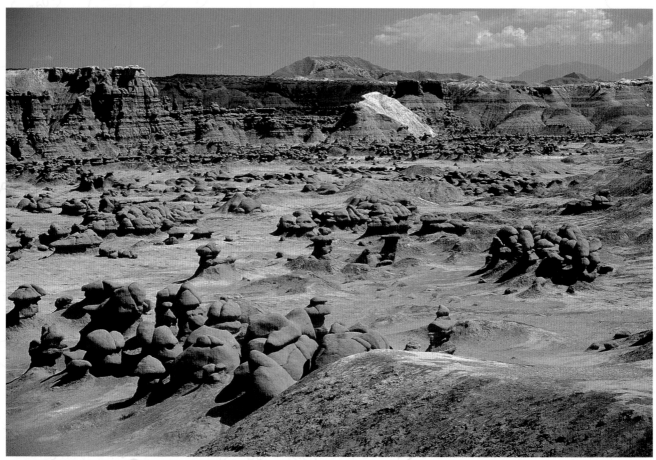

Goblin Valley and the remote Henry Mountains

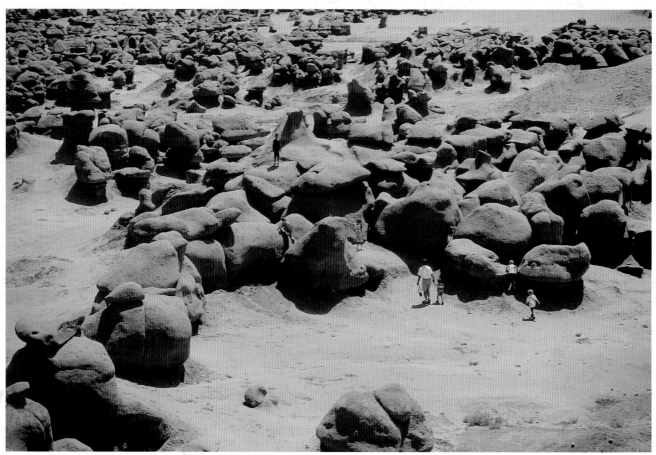

At play among the goblins

GOBLIN VALLEY
State Park

LOCATION: Central Utah, midway between I–70 and Hanksville

ELEVATION: 5,000 feet

AREA MAP: The turnoff to Goblin Valley State Park is Temple Mountain Road, located 25 miles south of I–70 on UT 24, near Mile Marker 137. Drive 5 miles west, then another 7 miles south on Goblin Valley Road. The park is just beyond Wild Horse Butte, which looms northwest of the park.

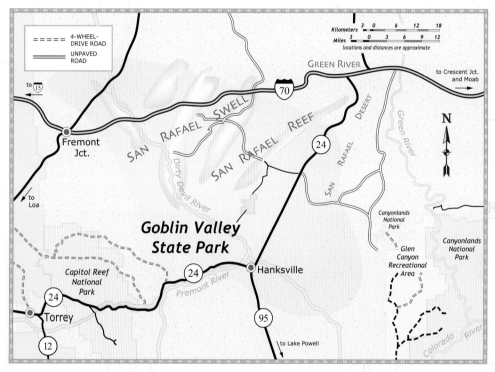

GEOLOGY: Goblin Valley State Park lies at the base of the San Rafael Reef, the scalloped eastern edge of a huge anticline called the San Rafael Swell. Here, a small area has been wildly eroded (by spheroidal weathering) into thousands of "goblins," oddly shaped mudhills of mocha brown Entrada sandstone capped with a tinge of greenish white Curtis formation.

SUGGESTED LENGTH OF STAY: 2 hours

BEST TIME TO BE THERE: Anytime except in the oppressive midday heat of summer, ideally under an interesting sky

HIGHLIGHTS: A velvet sky studded with a dusting of starlight hangs thick over us as we sail into the great shadowy waves of empty earth that carry our solitary ship onward. We are deep in the Swell now, and the ghosts of San Rafael are rising all around under a cold and ghastly moon. Goblins gather, thousands at a time in the valley to the west, to shake off the patient hours of stony silence spent under the blazing sun, and wild horses stretch their sandstone necks in a freedom run out on the mesa.

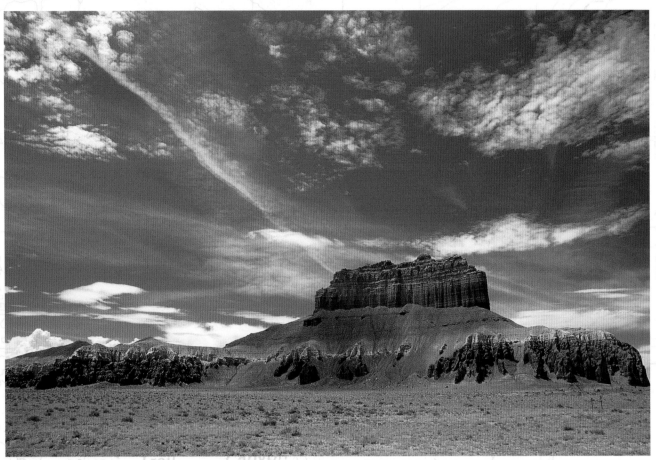

Wild Horse Butte

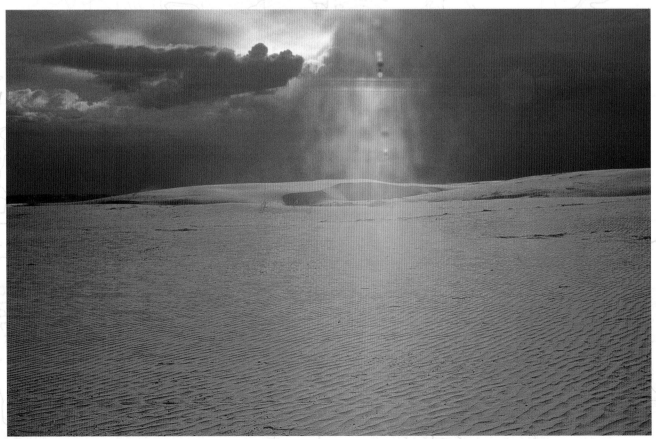

Along UT 24 near Goblin Valley

Scenic UT 24 from Goblin Valley to Capitol Reef passes through some of the most isolated and gorgeous landscape in Utah:

• stark mesas and buttes

• unearthly lava flows

• stretches of desolate flatland

• painted desert—softly rounded repeating forms, shoulders of eroded ridges in maroon, slate blue, deep gray, and white

• shallow, damp streambeds lined with cottonwood

• the dark lacolithic peaks of the wild and distant Henry Mountains

COLORFUL NOTE

Discovered in the 1920s, Goblin Valley was originally named Mushroom Valley after the whimsically grotesque toadstool-shaped formations that litter the park.

GENERAL INFORMATION

FEE:	Yes	CONVENIENCE STORE:	No
VISITOR CENTER:	No	HIKING:	Yes
4WD NEEDED:	No	CAMPING:	Yes
GAS WITHIN 5 MILES:	No	LODGING WITHIN 5 MILES:	No
RESTROOMS:	No	PHOTO RATING (1–5):	3.5
FOOD/WATER:	No	CHILD RATING (1–5):	5

NOTE: Open year-round, the campgrounds at Goblin Valley State Park (complete with potable water, solar-powered showers, and flush toilets) serve as an excellent base for hikers interested in exploring the San Rafael Reef and Swell.

CAUTION: Goblin Valley is in a remote, flat, and open area of the rocky San Rafael Desert, exposed to blistering sun and sudden extremes of weather. There is one shade canopy at Observation Point but no enclosed structures in which to take shelter.

FOR MORE INFORMATION

Goblin Valley State Park
P.O. Box 637
Green River, UT 84525-0637
(435) 564–3633
www.stateparks.utah.gov

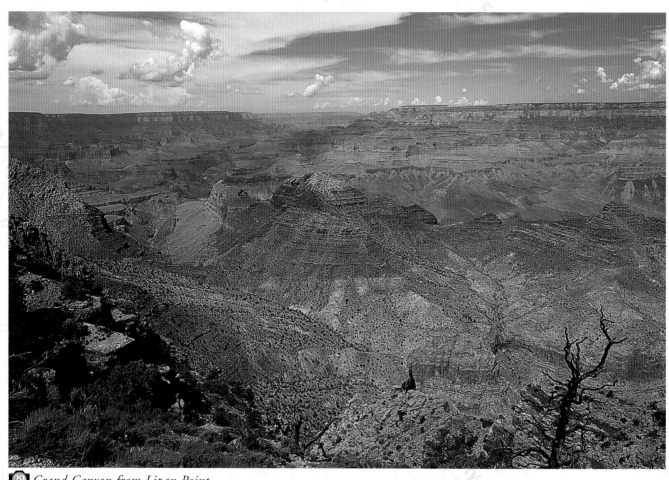

29 *Grand Canyon from Lipan Point*

GRAND CANYON
National Park (South Rim)

LOCATION: Northern Arizona

ELEVATION: Ranges from about 1,200 feet at Grand Wash to about 6,900 feet on the rim

PAIUTE NAME: *Kaibab*—"mountains lying down"

AREA MAP

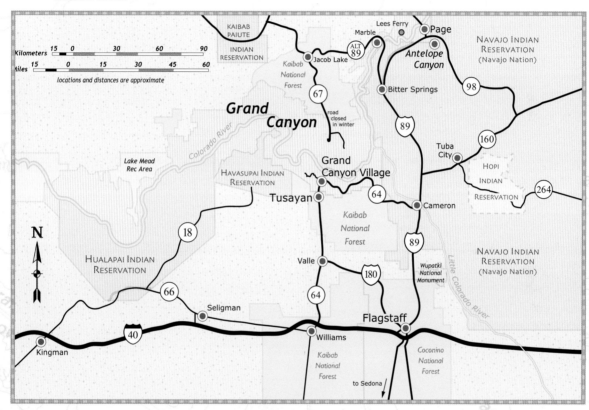

GEOLOGY: This magnificent creation of nature is unsurpassed in magnitude, grandeur, beauty, and geological significance. One mile deep and 10 miles from rim to rim, this rocky masterpiece is the work of the mighty Colorado River over the past five million years. In its length of 277 miles, the Grand Canyon region contains five of the seven life zones found in the Northern Hemisphere and is the only place on earth where such a glimpse back in time (two billion years and four geologic eras) is so clearly displayed in rock strata.

SUGGESTED LENGTH OF STAY: 3 to 5 days

BEST TIME TO BE THERE: Dawn or dusk

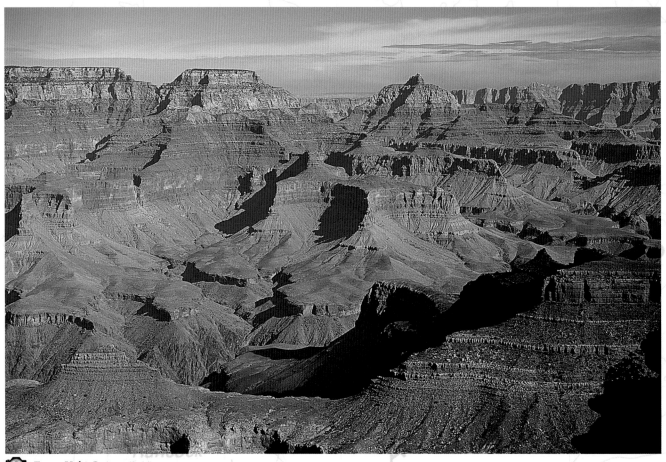

30 *From Yaki Point, 5:30 P.M.*

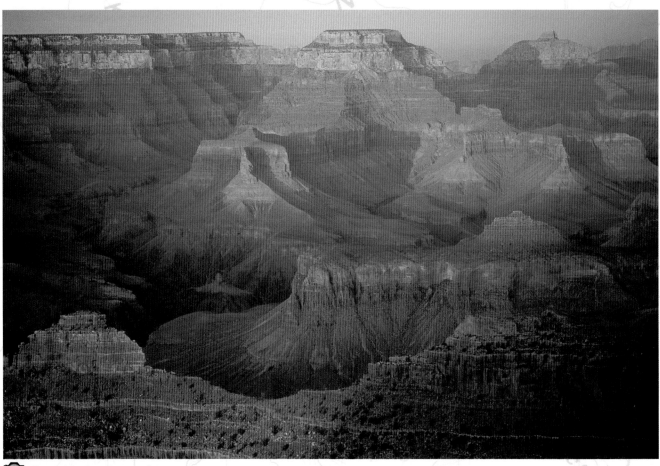

31 *From Mather Point, 6:30 P.M.*

GRAND CANYON
National Park (South Rim)

LOCAL MAPS

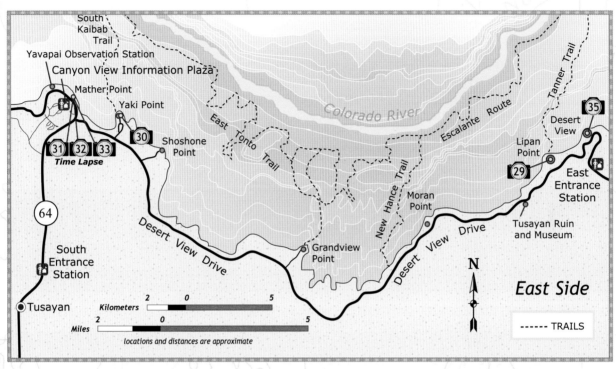

South
Kaibab
Trail
Yavapai Observation Station
Canyon View Information Plaza
Mather Point
Yaki Point
30
Shoshone
Point
31 32 33
Time Lapse
64
South
Entrance
Station
Tusayan

Colorado River
East Tonto Trail
New Hance Trail
Escalante Route
Tanner Trail
Desert View
35
Desert
View
Lipan
Point
29
East
Entrance
Station
Tusayan Ruin
and Museum
Moran
Point
Desert View Drive
Grandview
Point

N

East Side

Kilometers 2 0 5
Miles 2 0 5
locations and distances are approximate

----- TRAILS

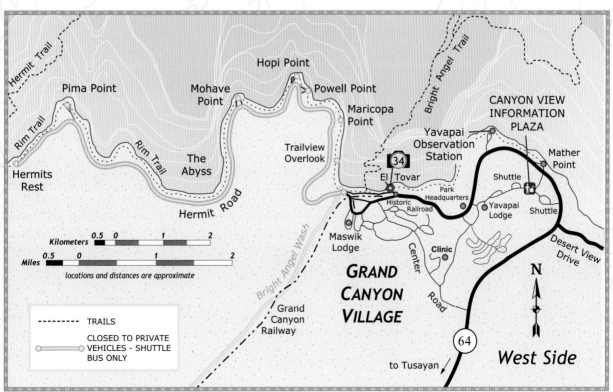

Hermit Trail
Pima Point
Hopi Point
Mohave
Point
Powell Point
Maricopa
Point
Bright Angel Trail
CANYON VIEW
INFORMATION
PLAZA
Rim Trail
Trailview
Overlook
Yavapai
Observation
Station
Mather
Point
The
Abyss
34
El Tovar
Shuttle
Hermits
Rest
Rim Trail
Historic
Railroad
Park
Headquarters
Yavapai
Lodge
Shuttle
Hermit Road
Maswik
Lodge
Clinic
Desert View
Drive
Bright Angel Wash
Center
Road
**GRAND
CANYON
VILLAGE**
N
64
Grand
Canyon
Railway
to Tusayan
West Side

Kilometers 0.5 0 1 2
Miles 0.5 0 1 2
locations and distances are approximate

-------- TRAILS

○——○ CLOSED TO PRIVATE
VEHICLES - SHUTTLE
BUS ONLY

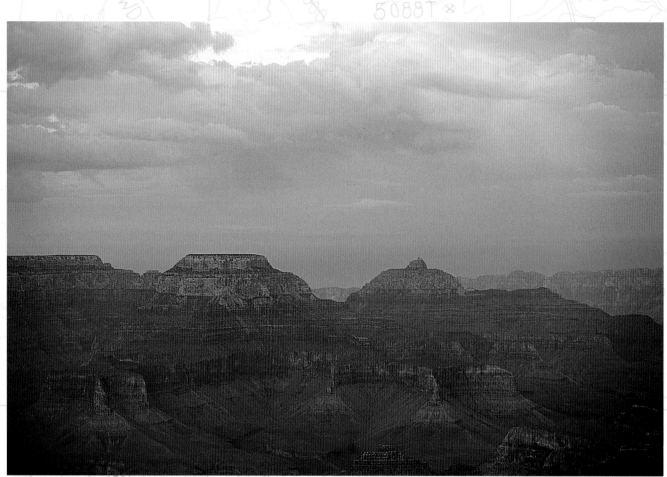

32 *From Mather Point, 7:30* P.M.

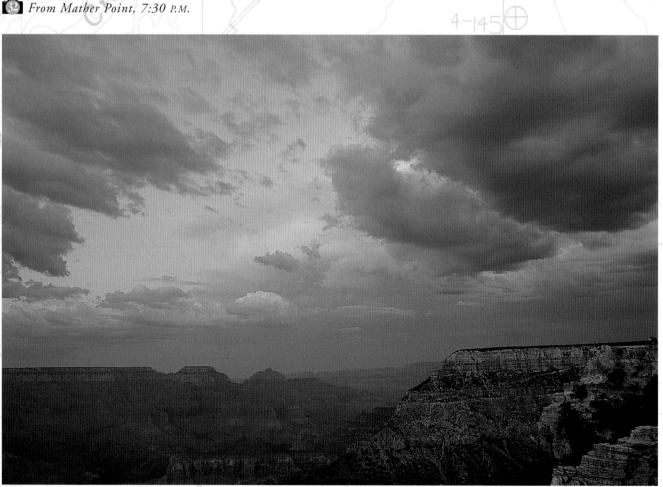

33 *From Mather Point, 8:00* P.M.

HIGHLIGHTS: To comprehend the Grand Canyon, one must engage all its elements: rock, water, light, and space, from the rim, from the river, from the trails, from the air. Waves of color like ribbons paint the unearthly expanse, the layered cliffs and floating islands of stone. Light seeps into the shadowy side canyons. At twilight, sharp edges dissolve, and gold, crimson, auburn, and violet fade slowly to a deep blue mist in the failing light. The Grand Canyon is so enormous that no sound or movement is sensed from the rim, only vast, silent stillness, incomprehensible to the mind and overwhelming to the soul.

Night surrenders to the sweeping light of daybreak everywhere on the rim. Carry a flashlight, and plan to arrive thirty minutes before sunrise.

Mather Point's western spur is perhaps the best overlook from which to watch as the evening sky spills its color into the canyon. Plan to arrive about two hours before sunset.

The historic El Tovar Hotel, built in 1905 of Douglas fir and native stone, keeps a tenuous hold on the rim's edge. Make reservations far in advance.

National Geographic's unforgettable film, *Grand Canyon—The Hidden Secrets*, is shown in the breathtaking reality of IMAX film technology. It plays hourly on the half hour in Tusayan's Grand Canyon IMAX Theater, which is equipped with a seven-story screen and a six-track sound system.

Hiking down into the canyon to the Phantom Ranch on the Colorado River has been likened to climbing a mountain in reverse. And as in mountain climbing, the ascent to the rim is more difficult than the descent and takes about twice as long. Depart early in the morning to avoid midafternoon heat. Be sure to carry plenty of water and drink it continuously. For the trip down, many take the steeper, less traveled South Kaibab Trail (7.3 miles) near Yaki Point. Return to the rim on the gentler Bright Angel Trail (9.3 miles), which has several water refill stops. This strenuous round-trip hike from the rim to the river and back should *never* be attempted in one day. Phantom Ranch (2,400 feet) provides basic accommodations, including bunk beds with sheets and towels, showers, flush toilets, breakfast, dinner, and a special gift shop for those who brave the adventure. Reservations are required and should be made one year in advance.

COLORFUL COMMENTS

NO MATTER HOW FAR YOU HAVE WANDERED HITHERTO, OR HOW MANY FAMOUS GORGES AND VALLEYS YOU HAVE SEEN, THIS ONE, THE GRAND CANYON OF THE COLORADO, WILL SEEM AS NOVEL TO YOU, AS UNEARTHLY IN THE COLOR AND GRANDEUR AND QUANTITY OF ITS ARCHITECTURE, AS IF YOU HAD FOUND IT AFTER DEATH, ON SOME OTHER STAR. . . .

— JOHN MUIR, from "The Wild Parks and Forest Reservations of the West," *Atlantic Monthly*, January 1898

34 *Historic El Tovar Hotel*

GRAND CANYON
National Park (South Rim)

THERE ARE CLIFFS AND LEDGES OF ROCK—NOT SUCH LEDGES AS YOU MAY HAVE SEEN WHERE THE QUARRYMAN SPLITS HIS BLOCKS, BUT LEDGES FROM WHICH THE GODS MIGHT QUARRY MOUNTAINS . . . AND NOT SUCH CLIFFS AS YOU MAY HAVE SEEN WHERE THE SWALLOW BUILDS ITS NEST, BUT CLIFFS WHERE THE SOARING EAGLE IS LOST TO VIEW ERE HE REACHES THE SUMMIT . . . WHEREVER WE LOOK THERE IS BUT A WILDERNESS OF ROCKS; DEEP GORGES, WHERE THE RIVERS ARE LOST BELOW THE CLIFFS, AND TOWERS AND PINNACLES; AND TEN THOUSAND STRANGELY CARVED FORMS IN EVERY DIRECTION; AND BEYOND THEM MOUNTAINS BLENDING WITH THE CLOUDS.

—from *Exploration of the Colorado River of the West and Its Tributaries* (1875) by MAJOR JOHN WESLEY POWELL, one-armed Civil War (Union) veteran of Shiloh who, in 1869 with nine men and four rowboats, was the first to conquer the "mad waters" of the Colorado River in a canyon he called the "Great Unknown."

IN THE GRAND CANYON, ARIZONA HAS A NATURAL WONDER WHICH, SO FAR AS I KNOW, IS IN KIND ABSOLUTELY UNPARALLELED THROUGHOUT THE REST OF THE WORLD. I WANT TO ASK YOU TO DO ONE THING . . . TO KEEP THIS GREAT WONDER OF NATURE AS IT NOW IS. . . . I HOPE YOU WILL NOT HAVE A BUILDING OF ANY KIND, NOT A SUMMER COTTAGE, A HOTEL OR ANYTHING ELSE, TO MAR THE WONDERFUL GRANDEUR, THE SUBLIMITY, THE GREAT LOVELINESS AND BEAUTY OF THE CANYON. LEAVE IT AS IT IS. YOU CANNOT IMPROVE UPON IT. THE AGES HAVE BEEN AT WORK ON IT, AND MAN CAN ONLY MAR IT. WHAT YOU CAN DO IS KEEP IT FOR YOUR CHILDREN, YOUR CHILDREN'S CHILDREN, AND FOR ALL WHO COME AFTER YOU, AS THE ONE GREAT SIGHT WHICH EVERY AMERICAN . . . SHOULD SEE.

—PRESIDENT THEODORE ROOSEVELT, 1903

THERE GOES GOD WITH AN ARMY OF BANNERS.

—CARL SANDBURG

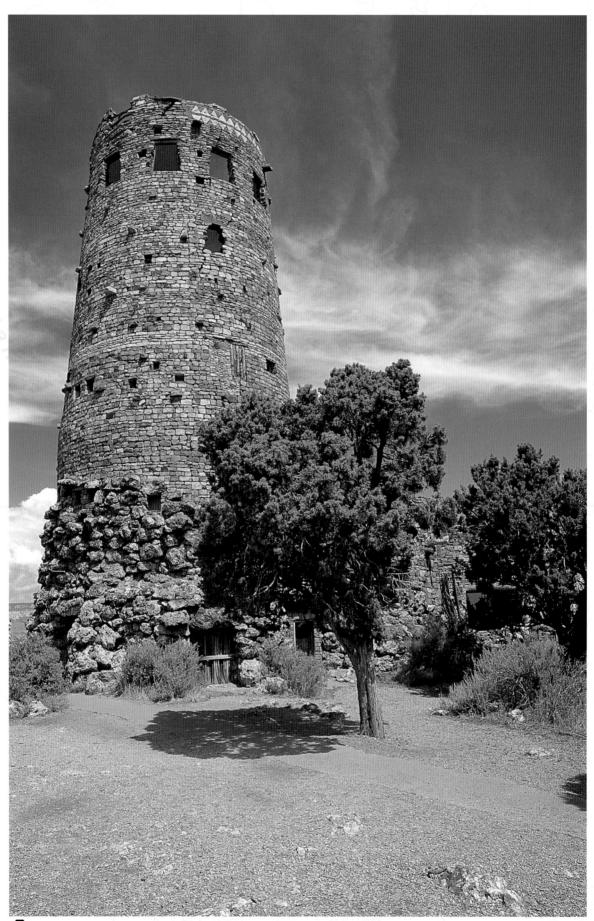
35 *Watchtower at Desert View*

GENERAL INFORMATION

FEE:	Yes	CONVENIENCE STORE:	Yes
VISITOR CENTER:	Yes	HIKING:	Yes
4WD NEEDED:	No	CAMPING:	Yes
GAS WITHIN 5 MILES:	Yes	LODGING WITHIN 5 MILES:	Yes
RESTROOMS:	Yes	PHOTO RATING (1–5):	5
FOOD/WATER:	Yes	CHILD RATING (1–5):	5

CAUTION: It is not possible to prepare fully for one's first experience at the Grand Canyon, but gathering information in advance will help define your choices. All activities in Grand Canyon National Park should be approached with common sense and knowledge, as preparation is the key to safety.

• Hiking down into the canyon should be attempted by only the most physically fit.

• Heat stroke, dehydration, sunburn, and exhaustion are very real possibilities, and medical assistance is not immediately available.

• At least 1 gallon of water per person per day is the general guideline for water consumption by hikers in the dry summer heat.

• Respect and obey all regulations and recommendations published or posted by the National Park Service.

• Stay behind the guardrails at all times, for the terrain at the rim's edge is unstable and can give way under foot.

Grand Canyon National Park strains to accommodate its many visitors, especially under the press of summer crowds. Hermit Road is closed to most private vehicles from March through November but is well served by the free shuttle system operated by the National Park Service.

FOR MORE INFORMATION

Superintendent
P.O. Box 129
Grand Canyon, AZ 86023
(928) 638–7888
www.nps.gov/grca

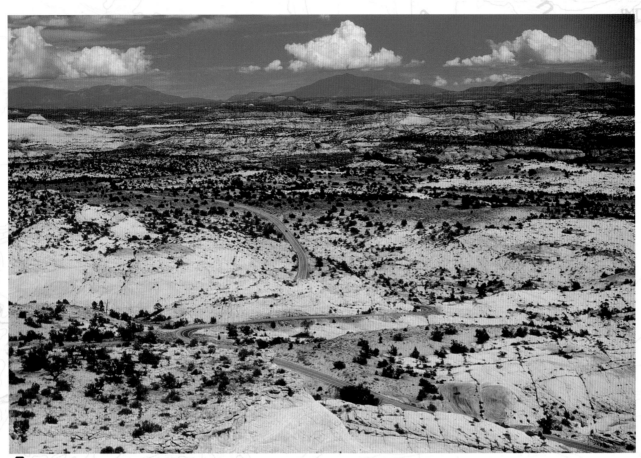

36 Highway 12 Scenic Byway

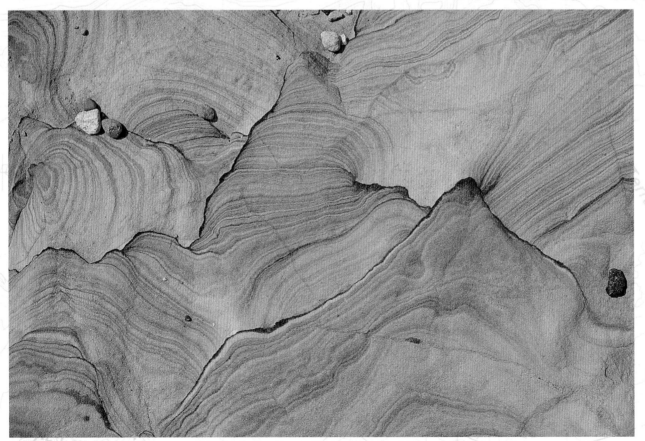

The elements trace delicate patterns in sandstone

GRAND STAIRCASE–ESCALANTE
National Monument

LOCATION: Central southern Utah

ELEVATION: Ranges from 4,000 feet at Wally Creek to 8,637 feet just south of Canaan Peak

AREA MAP: Paved access to Grand Staircase–Escalante National Monument is limited to UT 12 from the north and US 89 from the south.

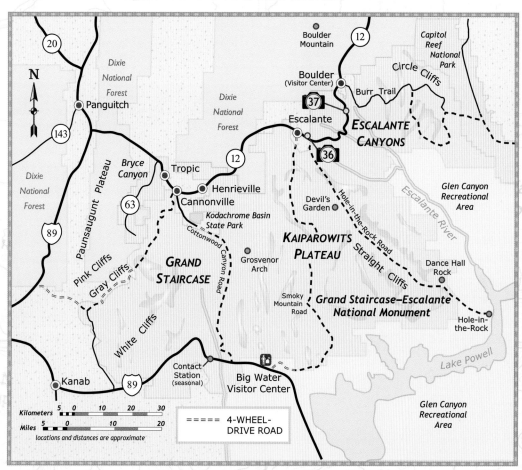

GEOLOGY: Designated in 1996 by presidential proclamation, the Grand Staircase–Escalante National Monument is a wild and undeveloped area that extends from Bryce Canyon northeast to the Waterpocket Fold and southeast to Lake Powell. At 2,700 square miles, it is staggering in size, with terrain so punishing that paved roads can only skirt its outer edges. It is divided naturally into three distinct geologic sections.

Treaded through the northeastern region are the Canyons of Escalante, an inaccessible network of waterworn gashes carved by the Escalante River and its winding tributaries.

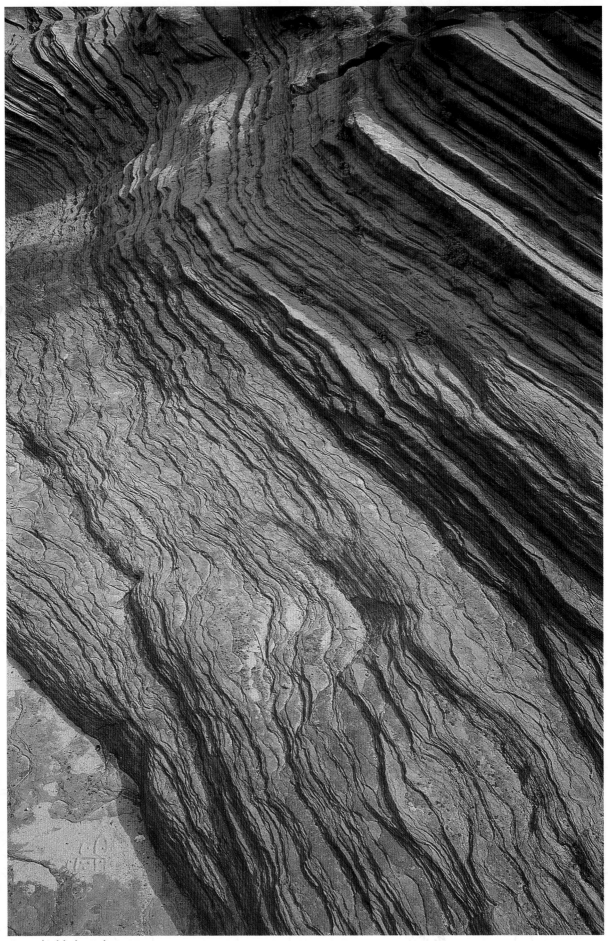

Cross-bedded sandstone

GRAND STAIRCASE—ESCALANTE
National Monument

The central region consists of the 800,000-acre Kaiparowits Plateau that fans out in a giant wedge from the town of Escalante south to Lake Powell and the Paria Plateau. A jumbled maze of wild flatlands and gorges, this area is the highest and most remote. It is entirely isolated from the Escalante Canyons by the 42-mile-long Straight Cliffs and blocked off from the west by the impenetrable fins of the Cockscomb Formation.

Farther to the west rises the Grand Staircase, a term coined by geologist Clarence E. Dutton (1841–1912) to describe the series of broad uptilted terraces that ascend like steps from the Kaibab Plateau at the Grand Canyon's North Rim to the Aquarius Plateau above Bryce Canyon. Ribbons of color in thin strips and broad strokes follow the warps and folds of layered earth split open and displaced during the uplift.

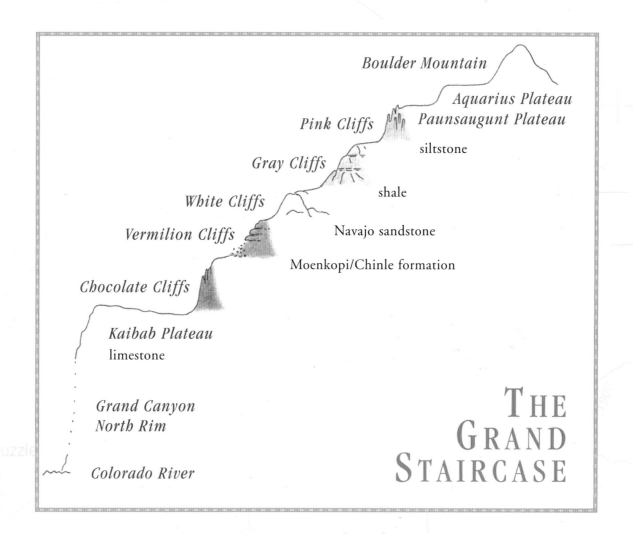

Boulder Mountain

Aquarius Plateau
Paunsaugunt Plateau

Pink Cliffs

siltstone

Gray Cliffs

shale

White Cliffs

Vermilion Cliffs

Navajo sandstone

Moenkopi/Chinle formation

Chocolate Cliffs

Kaibab Plateau
limestone

Grand Canyon
North Rim

Colorado River

THE
GRAND
STAIRCASE

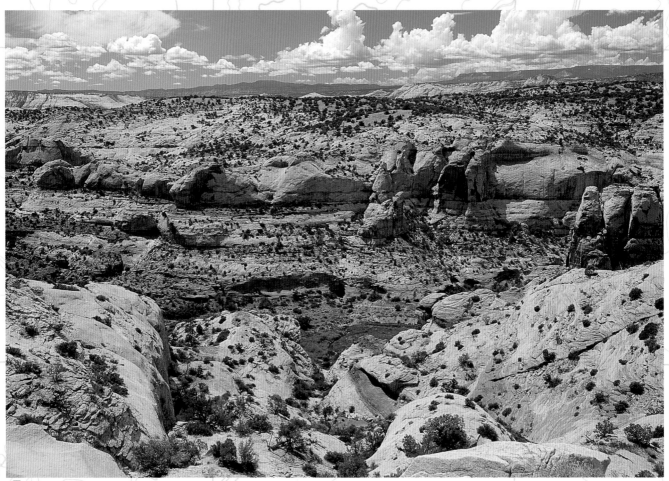

37 *Along the Hogsback*

Dixie National Forest near Bown's Lake

GRAND
STAIRCASE–ESCALANTE
National Monument

HIGHLIGHTS:

• **The great diversity of wilderness:**

 –intricate canyon systems of the Escalante and Paria Rivers

 –buttes, mesas, plateaus, pinnacles, natural arches, and stone bridges

 –stretches of high arid desert and dense forest

 –valleys lush with junipers, cottonwood, scrub oak, and willows supporting wild birds and mammals

 –petrified wood and fossils of dinosaur and marine life

 –ruins and petroglyphs from the Anasazi, Fremont, Southern Ute, and Navajo cultures

• **Highway 12 Scenic Byway from Escalante to Boulder:**

 Built in 1935 by the Civilian Conservation Corps, "The Million Dollar Road to Boulder" crosses a high and narrow ridge called the Hogsback. On either side, steep, twisting cliffs plunge into the depths of the Escalante Canyons below.

• **Scenic Backways (four-wheel drive recommended, dry conditions only):**

 The Burr Trail winds southeast for 66 miles from Boulder through Capitol Reef National Park and the Glen Canyon National Recreation Area to Bullfrog Marina at Lake Powell. It travels along the bottom of spectacular Long Canyon, rocky and colorful, to Deer Creek, slot canyons, and the stunning wilderness of the Waterpocket Fold.

 The Devil's Garden, 18 miles south of Escalante along the 56-mile Hole-in-the-Rock Road, features an assortment of arches and bizarre rock sculpture.

 The gorgeous Cottonwood Canyon Road extends south for 46 miles from Kodachrome Basin State Park, past Grosvenor Arch, and into the Cockscomb Formation and the Paria River canyons.

 Smoky Mountain Road, a 78-mile rugged stretch of dirt and gravel, connects UT 12 in the north and US 89 in the south.

GENERAL INFORMATION

FEE:	Yes	CONVENIENCE STORE:	No
VISITOR CENTER:	Yes	HIKING:	Yes
4WD NEEDED:	Yes	CAMPING:	Yes
GAS WITHIN 5 MILES:	No	LODGING WITHIN 5 MILES:	No
RESTROOMS:	Yes	PHOTO RATING (1–5):	3.5
FOOD/WATER:	No	CHILD RATING (1–5):	2

FOR MORE INFORMATION

Grand Staircase–Escalante National Monument
P.O. Box 225
Escalante, UT 84726
(435) 826–5499
www.ut.blm.gov/monument

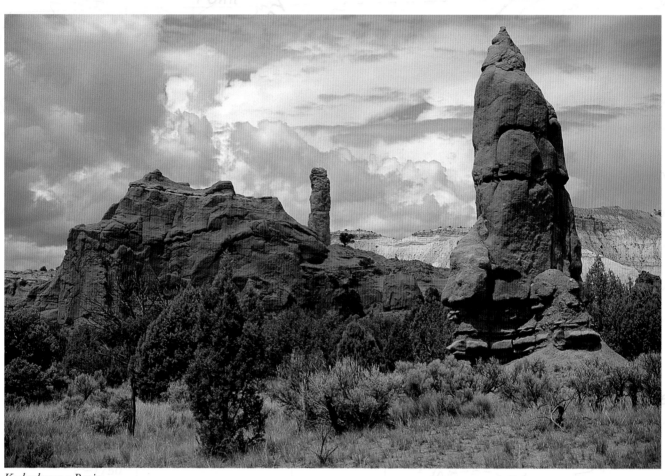

Kodachrome Basin

KODACHROME BASIN
State Park

LOCATION: Near Cannonville, Utah

ELEVATION: 5,800 feet

AREA MAP: The turnoff to Kodachrome Basin State Park is located in Cannonville, 12 miles east of Bryce Canyon on UT 12. Drive 7.75 miles on Cottonwood Canyon Road to the park entrance.

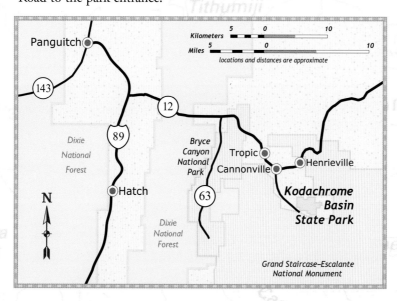

LOCAL MAP

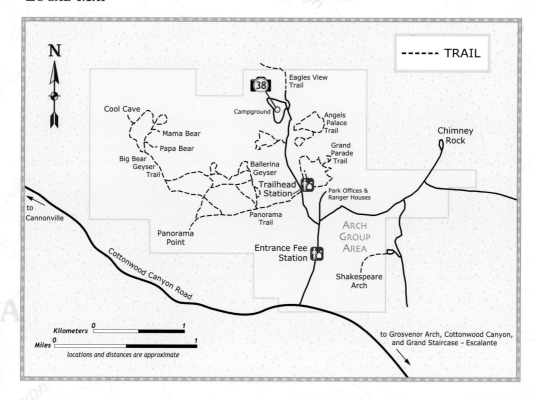

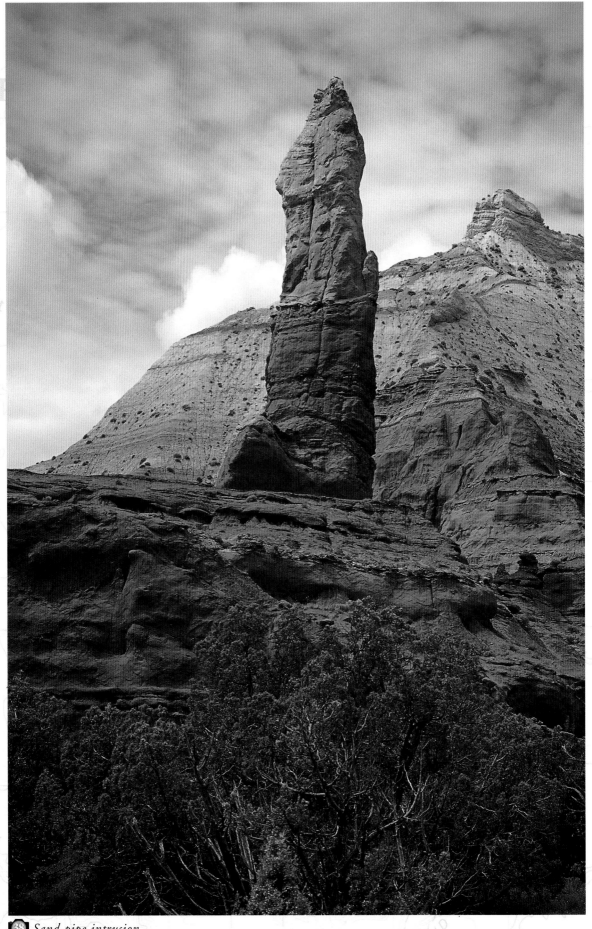

38 *Sand-pipe intrusion*

KODACHROME BASIN
State Park

GEOLOGY: Isolated and unspoiled, Kodachrome Basin State Park contains an impressive assortment (sixty-seven in all) of freestanding sand-pipe intrusions, or "chimneys." Ranging from 10 to 170 feet, they are believed to be the sedimentary cores of ancient geysers that were exposed as the surrounding Entrada sandstone weathered away.

SUGGESTED LENGTH OF STAY: 1 to 2 days

BEST TIME TO BE THERE: Late afternoon, near sunset

HIGHLIGHTS: Kodachrome Basin State Park offers activities and excellent camping facilities for group and family gatherings, such as restrooms, showers, firewood, barbecue grills, a convenience store, and horseback and stagecoach rides. At sunset, an eerie glow lights the fiery colors of these spindly rock columns, misshapen monoliths, and weirdly eroded spires jutting up from the basin floor.

COLORFUL NOTE

During a photography expedition in 1948, the National Geographic Society named the park "Kodachrome Flat" after Kodak's famous color slide film.

GENERAL INFORMATION

FEE:	Yes	**CONVENIENCE STORE:**	Yes
VISITOR CENTER:	No	**HIKING:**	Yes
4WD NEEDED:	No	**CAMPING:**	Yes
GAS WITHIN 5 MILES:	No	**LODGING WITHIN 5 MILES:**	No
RESTROOMS:	Yes	**PHOTO RATING (1–5):**	3.5
FOOD/WATER:	Yes	**CHILD RATING (1–5):**	3.5

FOR MORE INFORMATION

Kodachrome Basin State Park
P.O. Box 180069
Cannonville, UT 84718-0069
(435) 679–8562
www.stateparks.utah.gov

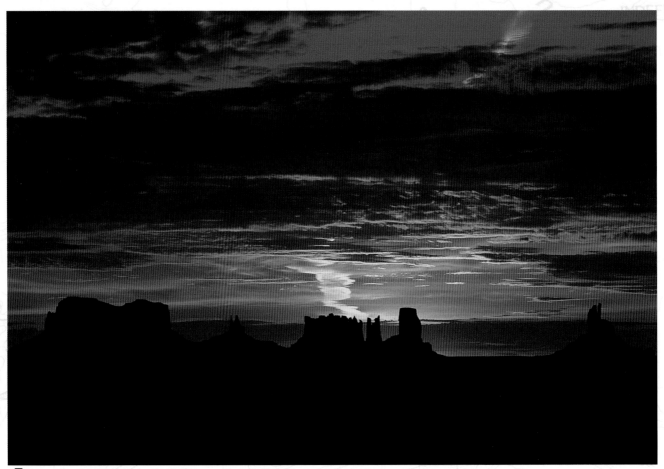

39 *Summer sunrise*

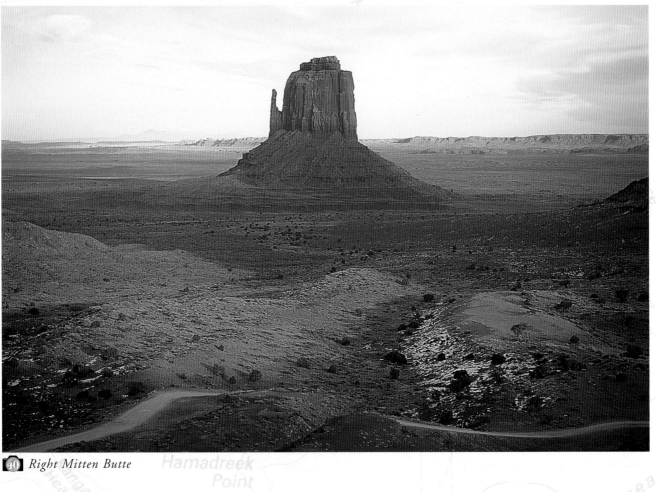

40 *Right Mitten Butte*

MONUMENT VALLEY
Navajo Tribal Park

LOCATION: Monument Valley, Arizona, within the Navajo (Dineh) Nation

ELEVATION: 5,564 feet

NAVAJO NAME: *Tse Bii' Ndzisgaii*—"clearings among the rocks"

AREA MAP: Monument Valley is located about 22 miles northeast of Kayenta, Arizona.

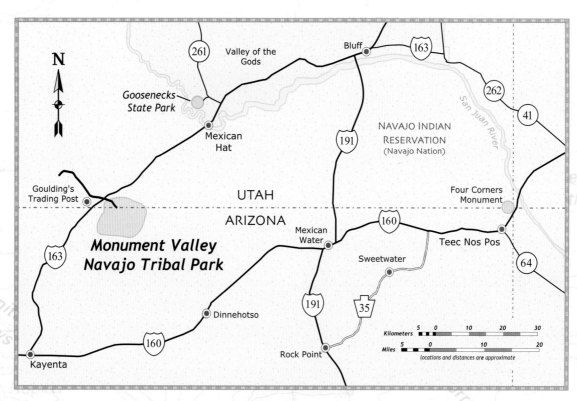

GEOLOGY: Gradual uplift and erosion of what was once a great inland seabed have produced the unearthly landscape of Monument Valley. As soft layers of de Chelly sandstone are worn away into dunes of drifting sand, the resistant harder rock remains. Left standing are wind-whipped buttes and mesas of all shapes and sizes, splintered monoliths rising from crumbling, sloped bases, and fantastic spires that tower 400 to 1,200 feet above the mile-high desert floor.

SUGGESTED LENGTH OF STAY: 2 days

BEST TIME TO BE THERE: Sunrise and sunset

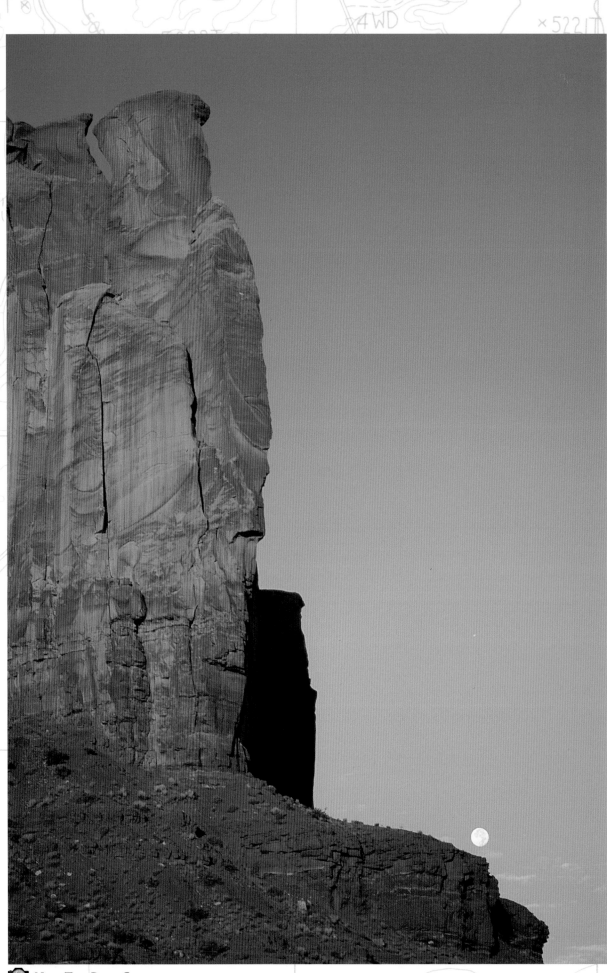

41 *Near Two Door Canyon*

MONUMENT VALLEY
Navajo Tribal Park

LOCAL MAP

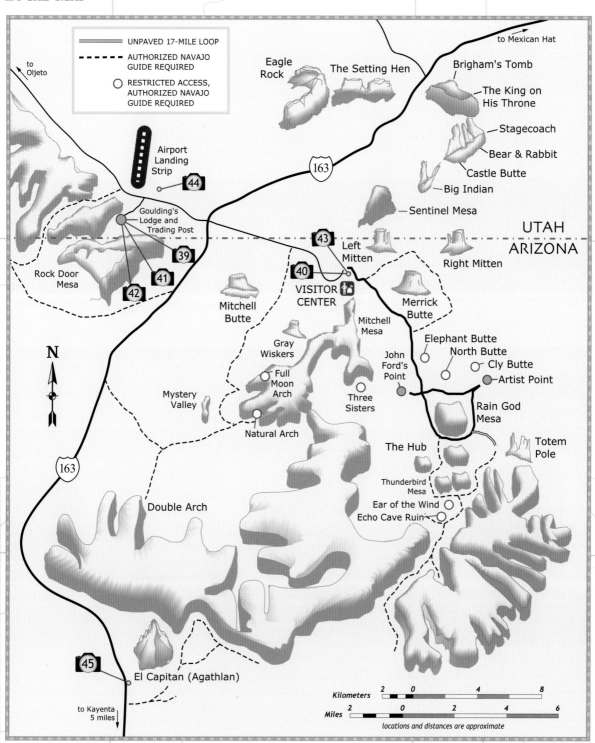

——— UNPAVED 17-MILE LOOP

- - - - AUTHORIZED NAVAJO GUIDE REQUIRED

○ RESTRICTED ACCESS, AUTHORIZED NAVAJO GUIDE REQUIRED

to Oljeto

to Mexican Hat

Eagle Rock

The Setting Hen

Brigham's Tomb

The King on His Throne

Stagecoach

Bear & Rabbit

Castle Butte

Big Indian

Sentinel Mesa

Airport Landing Strip

44

163

Goulding's Lodge and Trading Post

39

43

Left Mitten

UTAH
ARIZONA

Right Mitten

41

40

42

VISITOR CENTER

Merrick Butte

Rock Door Mesa

Mitchell Butte

Mitchell Mesa

Elephant Butte
North Butte

Gray Wiskers

John Ford's Point

Cly Butte

Artist Point

N

Full Moon Arch

Three Sisters

Mystery Valley

Rain God Mesa

Totem Pole

Natural Arch

The Hub

Thunderbird Mesa

163

Double Arch

Ear of the Wind

Echo Cave Ruin

Kilometers 2 0 4 8

Miles 2 0 2 4 6

45

El Capitan (Agathlan)

locations and distances are approximate

to Kayenta 5 miles

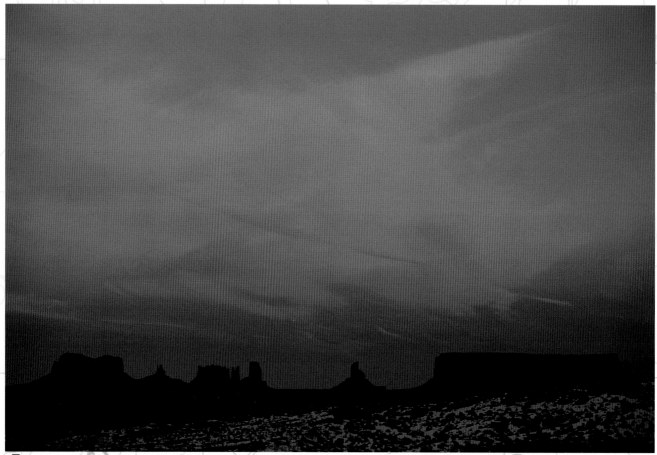

Winter sunset (from left to right): Brigham's Tomb, The King on His Throne, Stagecoach, Bear and Rabbit, Castle Butte, Big Indian, and Sentinel Mesa

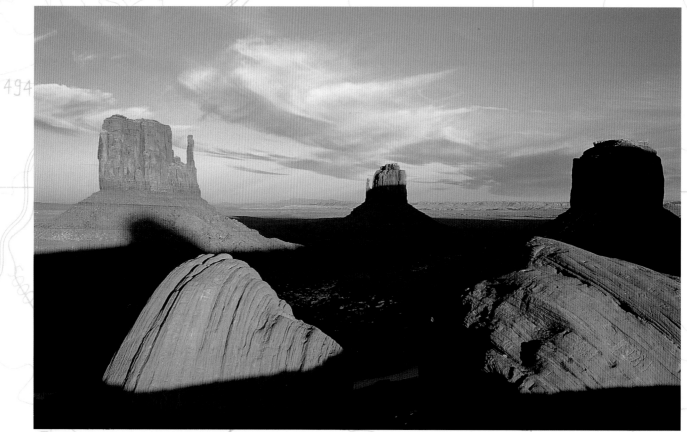

The Mittens and Merrick Butte

HIGHLIGHTS: Monument Valley is ancient and sacred Navajo land, and home to many who preserve the traditional way of life. The original trading post and ranch house at Goulding's Lodge is now a private historical museum featuring Anasazi artifacts, motion picture memorabilia, and cultural displays. Trained Navajo guides lead escorted tours to mud dwellings called hogans, rug-weaving demonstrations, and remote and spectacular regions of the valley, otherwise off-limits to public access. Open to the public, the 17-mile drive from the Visitor Center down into the valley offers views of the giant monuments from a very different perspective, but allows exploration of only a tiny fraction of this wild and fascinating land. If the surface is dry, the dusty unpaved road is bumpy but passable in a two-wheel-drive vehicle. Do not leave the public roads on foot or by car unless you are with a Navajo guide.

When approaching Monument Valley from the east, the following route is worth considering. Take US 160, which skirts Four Corners Monument, the only place in the nation where four states meet at a single point. Turn north on US 191 and then south on US 163 past Valley of the Gods, a gorgeous stretch of ragged cliffs. Continue on US 163 to the turnoff for Goosenecks State Park, just north on UT 261 (see Natural Bridges). Return to US 163 and continue south past the balanced rock known as Mexican Hat and on to Monument Valley.

Dawn comes up like fire over Monument Valley. The rock skyline, as seen in silhouette from Goulding's Lodge, resembles a strange procession of animals and odd figures moving silently across the horizon. At sunset, long, warm rays stretch across the famous Mitten Buttes as light is drawn from the valley. Shadows lengthen, and the earth's red heat cools to lavender and soft blue in the fading dusk.

COLORFUL NOTE

Monument Valley has been the setting for the filming of many famous westerns, notably those of director John Ford. Movies filmed entirely or partially in Monument Valley include *Stagecoach* (1939), *Kit Carson* (1940), *Billy the Kid* (1941), *My Darling Clementine* (1946), *Fort Apache* (1948), *She Wore a Yellow Ribbon* (1949), *The Searchers* (1956), *How the West Was Won* (1962), *The Trial of Billy Jack* (1973), *The Eiger Sanction* (1975), *The Legend of the Lone Ranger* (1981), *Back to the Future II* (1989) & *III* (1990), *Thelma and Louise* (1991), and *Forrest Gump* (1994).

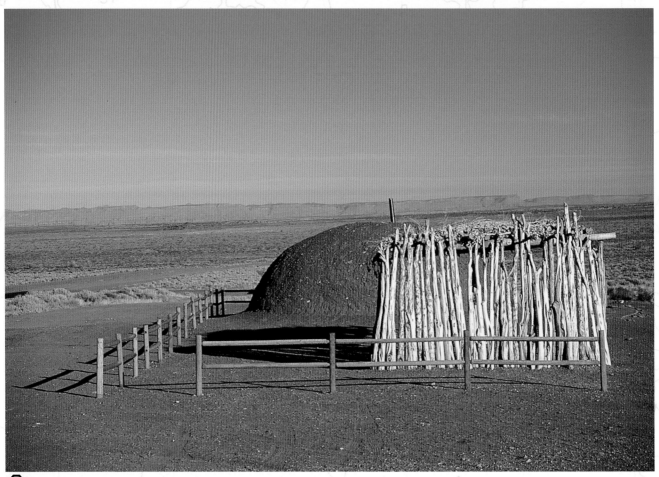

44 *Traditional hogan*

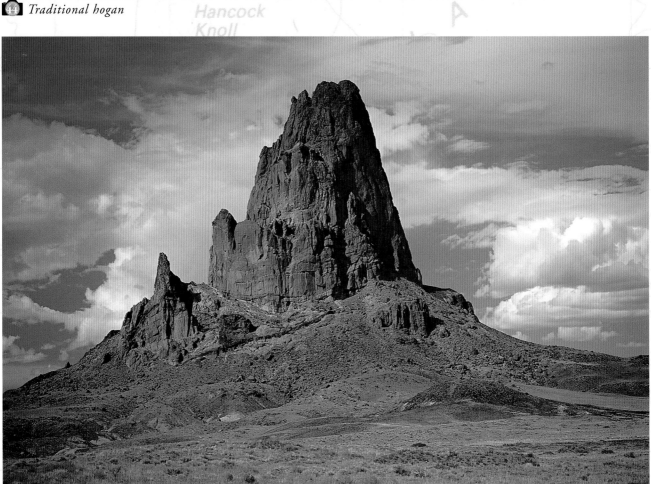

45 *El Capitan (Agathlan), the basalt core of an ancient volcano*

MONUMENT VALLEY
Navajo Tribal Park

GENERAL INFORMATION

FEE:	Yes	CONVENIENCE STORE:	Yes
VISITOR CENTER:	Yes	HIKING:	No
4WD NEEDED:	No	CAMPING:	Yes
GAS WITHIN 5 MILES:	Yes	LODGING WITHIN 5 MILES:	Yes*
RESTROOMS:	Yes	PHOTO RATING (1–5):	5
FOOD/WATER:	Yes	CHILD RATING (1–5):	4

NOTE: With the exception of the 17-mile loop around the monuments, all off-road driving or hiking in Monument Valley requires an authorized Navajo guide. Do not photograph Native Americans, their homes, or possessions without permission. It is customary to offer a gratuity for this privilege. Alcoholic beverages are prohibited on Navajo land.

FOR MORE INFORMATION

Monument Valley Navajo Tribal Park
P. O. Box 360289
Monument Valley, UT 84536
(435) 727–3287
www.navajonationparks.org

*Goulding's Lodge
P. O. Box 360001
Monument Valley, UT 84536
(435) 727–3231
(800) 874–0902

It may be necessary to call a year in advance to reserve a room at Goulding's Lodge during the summer. Request a room number between 203 and 217 for prime photography and unobstructed views from the room balcony.

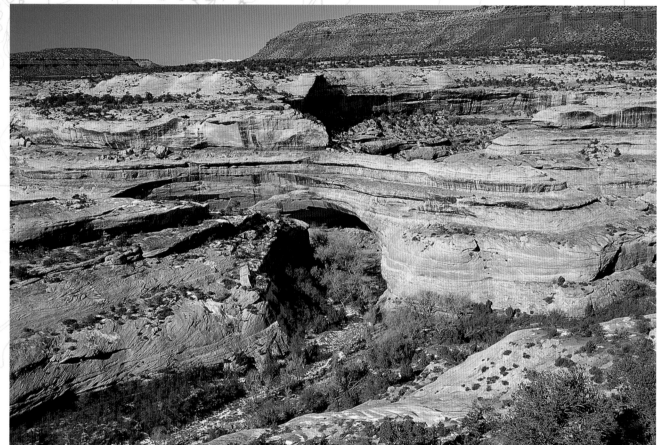

46 *Kachina Bridge*

NATURAL BRIDGES
National Monument

LOCATION: Southeastern Utah

ELEVATION: Ranges from 5,500 feet to 6,500 feet

PAIUTE NAME: *Ma-Vah-Talk-Tump*—"under the horse's belly"

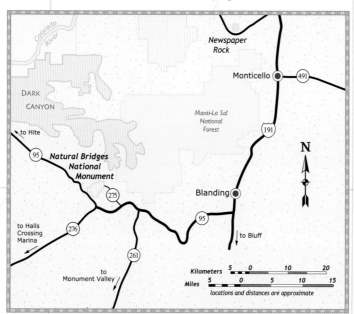

AREA MAP: Natural Bridges National Monument is located 42 miles west of Blanding, Utah, on UT 95.

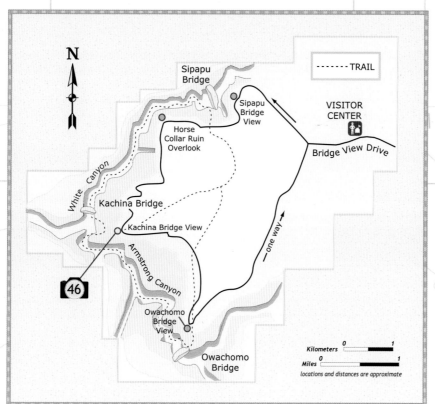

LOCAL MAP

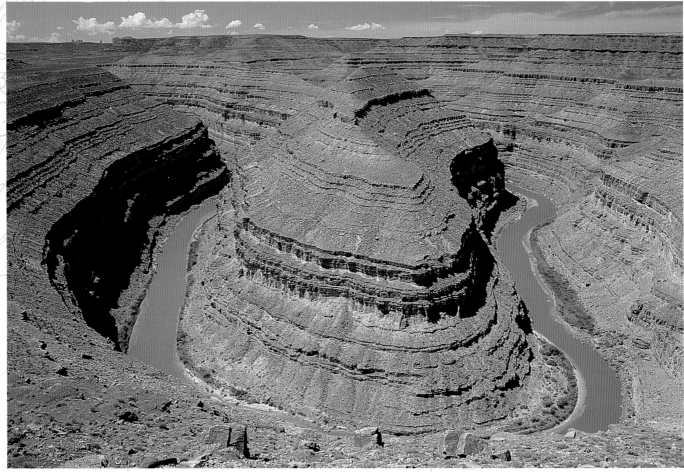

Nature at work making a natural bridge—shown here is one of four tight looping meanders formed by the silt-rich San Juan River at Goosenecks State Park, Utah. The span across all four goosenecks is 1 mile, but in that distance, the river travels 6 miles, at one point making a 3-mile curve around a wall of rock that is only 100 yards wide. Eventually this narrow wall will be breached, creating a new natural bridge.

NATURAL BRIDGES
National Monument

GEOLOGY: Within the deep and winding meanders of White and Armstrong Canyons, the subtle but persistent force of stream water has eroded and perforated massive Cedar Mesa sandstone walls to form three rare natural bridges.

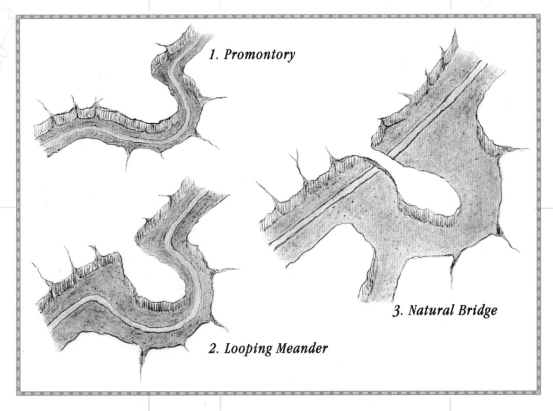

1. Promontory

2. Looping Meander

3. Natural Bridge

SUGGESTED LENGTH OF STAY: 2 hours to drive it or 2 days to explore it

HIGHLIGHTS: The 9-mile Bridge View Drive along the rim of the mesa provides access to overlooks and trailheads that lead down to each bridge. In the canyons below, a 7-mile trail connects all three bridges, which are about 3.5 miles apart.

BRIDGE NAME	KACHINA	SIPAPU	OWACHOMO
HOPI TRANSLATION	*spirit dancer*	*place of emergence*	*rock mound*
AGE	early stage	mature stage	late stage
LENGTH	204 feet	268 feet	180 feet
HEIGHT	210 feet	220 feet	106 feet
WIDTH	44 feet	31 feet	27 feet
THICKNESS	93 feet	53 feet	9 feet

Weathered rock in White Canyon

COLORFUL NOTES

Natural Bridges National Monument is home to an extensive solar photovoltaic system, which produces most of the park's electricity from sunlight.

In June, 1992 a section of Kachina Bridge cracked under its own weight, and rock slabs weighing 4,000 tons split off and crashed into the canyon.

At a point 10 miles north of Blanding on US 191 or at Mile Marker 98 on UT 95, the following can be seen as the eye sweeps northeast to southwest across the horizon for more than 200 miles: Lone Cone Peak, the San Miguel and La Plata Mountain Ranges, Mesa Verde, Sleeping Ute Mountain, Shiprock, Raplee Ridge, and Monument Valley.

GENERAL INFORMATION

FEE:	Yes	CONVENIENCE STORE:	No
VISITOR CENTER:	Yes	HIKING:	Yes
4WD NEEDED:	No	CAMPING:	Yes
GAS WITHIN 5 MILES:	No	LODGING WITHIN 5 MILES:	No
RESTROOMS:	Yes	PHOTO RATING (1–5):	2
FOOD/WATER:	No	CHILD RATING (1–5):	2

CAUTION: The trails to the bridges have many steep drop-offs and are without railings. Do not enter White or Armstrong Canyons during heavy or prolonged rain, as there is always a danger of flash flooding.

FOR MORE INFORMATION

Natural Bridges National Monument
HC 60 Box 1
Lake Powell, UT 84533-0101
(435) 692–1234
www.nps.gov/nabr

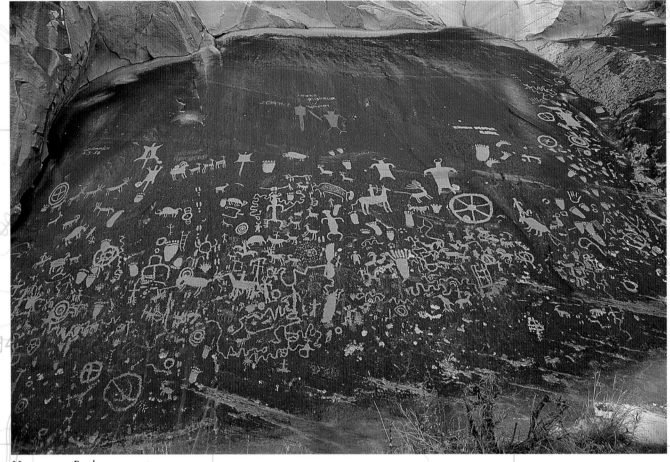

Newspaper Rock

NEWSPAPER ROCK

LOCATION: Near Monticello, Utah

ELEVATION: About 4,000 feet

NAVAJO NAME: *Tse Hani*—"rock that tells a story"

AREA MAP: From Monticello, drive 14 miles north on US 191, then 12 miles southwest on UT 211 into Indian Creek Canyon.

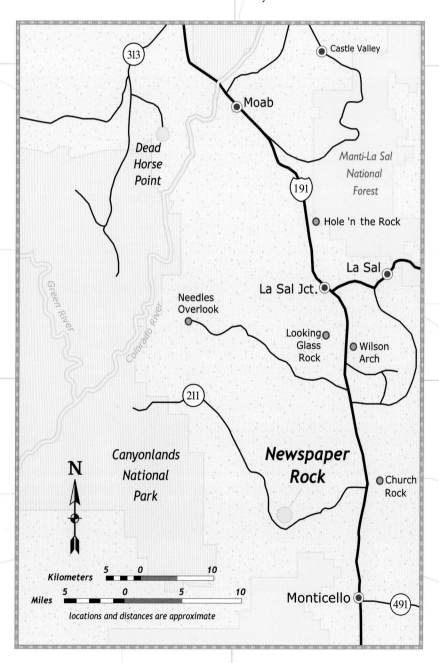

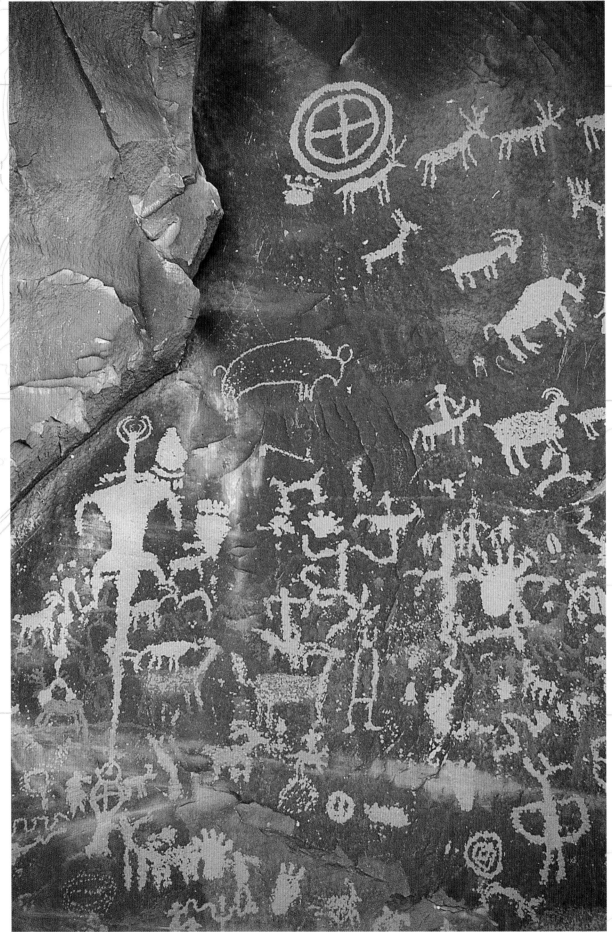

Petroglyphs and pictographs

NEWSPAPER ROCK

GEOLOGY: Newspaper Rock is a cliff mural, a vertical slab of desert-varnished Wingate sandstone that is covered with two millennia of petroglyphs and pictographs from many distinctive periods and cultures.

SUGGESTED LENGTH OF STAY: 1 hour

BEST TIME TO BE THERE: Midday

HIGHLIGHTS: While traveling along US 191 between Moab and Monticello, consider the following three stops, all just to the left of the road when heading south:

- **HOLE 'N THE ROCK,** 15 miles south of Moab, is a one-of-a-kind 5,000-square-foot home built by Albert and Gladys Christensen, entirely within an enormous sandstone formation. Years of dynamite blasting and excavation preceded construction, which began in 1945 and continued for about twenty years. The bare rock walls and floors provide such excellent insulation that no heat or air-conditioning is ever needed despite wide swings in the climate. The Christensens were simple, down-to-earth folks, and the decor reflects their heartfelt and handcrafted style. Many of Albert's paintings are on display, as well as his incredible carved portrait of Franklin D. Roosevelt that he chiseled into the face of the sandstone by his front door. For more information, call (435) 686–2250.

- **WILSON ARCH,** just south of La Sal Junction, is a classic example of a natural stone arch.

- **CHURCH ROCK,** about 42 miles south of Moab and 14 miles north of Monticello, marks the turnoff to Newspaper Rock and the Needles District of Canyonlands National Park.

GENERAL INFORMATION

FEE:	No	**CONVENIENCE STORE:**	No
VISITOR CENTER:	No	**HIKING:**	Yes
4WD NEEDED:	No	**CAMPING:**	No
GAS WITHIN 5 MILES:	No	**LODGING WITHIN 5 MILES:**	No
RESTROOMS:	Yes	**PHOTO RATING (1–5):**	2
FOOD/WATER:	No	**CHILD RATING (1–5):**	3.5

FOR MORE INFORMATION

Bureau of Land Management
Monticello Field Office
435 North Main Street
Monticello, Utah 84535
(435) 587–2141

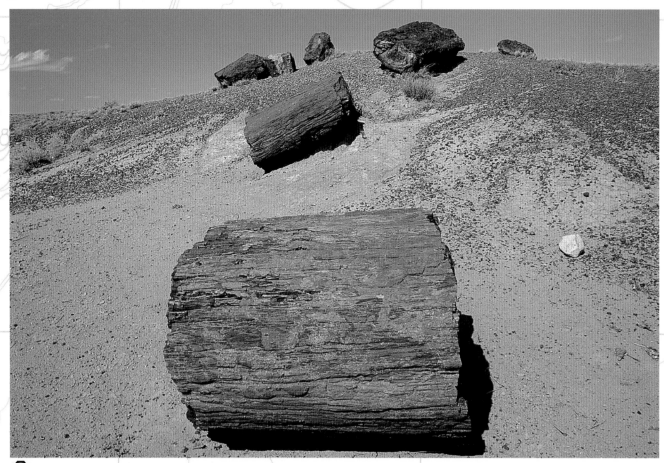

47 *Petrified logs in the Rainbow Forest District*

48 *Petrified wood in its natural state*

PETRIFIED FOREST
National Park

LOCATION: Near Holbrook, Arizona

ELEVATION: Ranges from about 5,300 feet at the Puerco River to 6,234 feet at Pilot Rock, a volcanic butte

AREA MAP: The 28-mile park drive runs between Exit 311 on I–40 to the north and AZ 180 to the south, about 25 miles east of Holbrook, Arizona. The park has an entrance and a visitor center at either end.

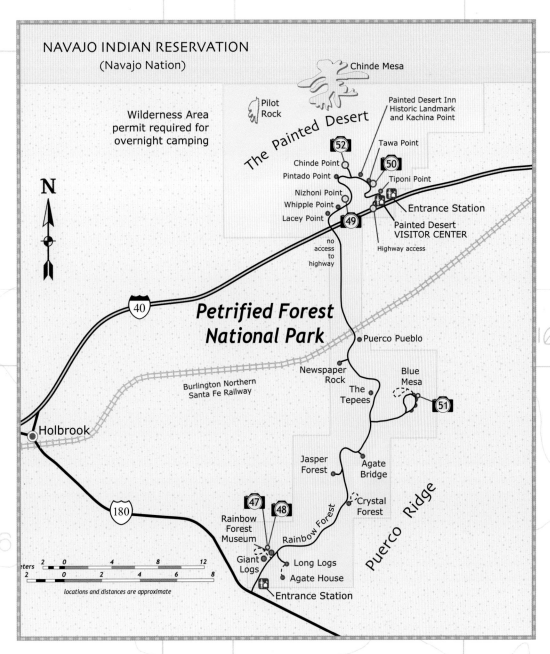

NAVAJO INDIAN RESERVATION
(Navajo Nation)

Chinde Mesa

Pilot Rock

Wilderness Area permit required for overnight camping

The Painted Desert

Painted Desert Inn Historic Landmark and Kachina Point

Tawa Point

Chinde Point
Pintado Point
Tiponi Point

Nizhoni Point
Whipple Point
Lacey Point

Entrance Station

Painted Desert VISITOR CENTER

Highway access

no access to highway

Petrified Forest National Park

Puerco Pueblo

Newspaper Rock

Blue Mesa

Burlington Northern Santa Fe Railway

The Tepees

Jasper Forest

Agate Bridge

Crystal Forest

Puerco Ridge

Holbrook

Rainbow Forest Museum

Rainbow Forest

Giant Logs
Long Logs
Agate House

Entrance Station

locations and distances are approximate

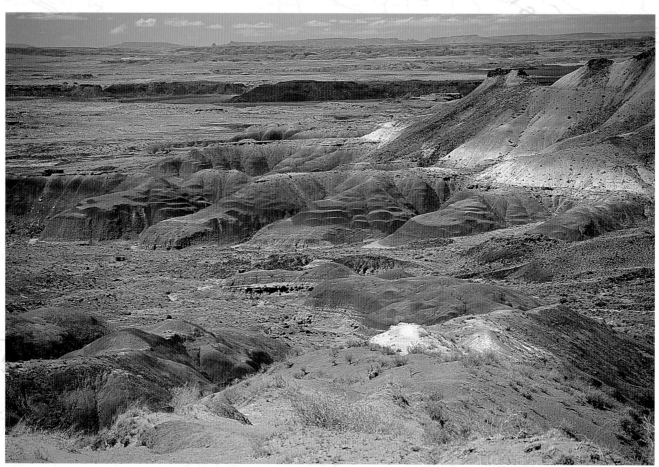

49 *From Nizhoni Point*

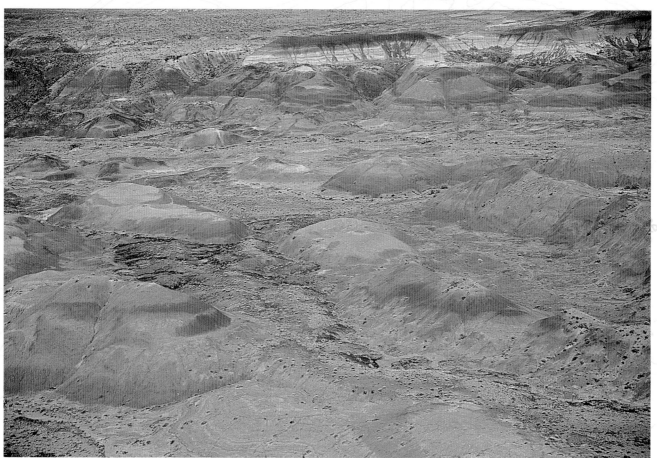

50 *From Tawa Point*

PETRIFIED FOREST
National Park

GEOLOGY: About 225 million years ago, ancient riverways transported thousands of tall pines to a freshwater swamp, where they became submerged and were protected from decay by mud, silt, and volcanic ash or silica. Groundwater rich in dissolved silica seeped into the cellular structure, allowing silica deposits to replace the wood, crystallizing entire trees to rock-hard mineral quartz. Later, during earthquakes or in the uplifting of the Colorado Plateau, these giant brittle fossils were fractured or split open as the bed of sandstone cracked apart under the stress of the upheaval. Gradually, erosion by wind and water exposed what remained, from the tiniest scattered fragments to massive complete logs of stone. In places, many are still buried deep within the surrounding sedimentary layers. The intense hues of red, purple, yellow, and orange are stains produced primarily by the oxides of manganese and iron.

SUGGESTED LENGTH OF STAY: 1 day

BEST TIME TO BE THERE: Midday or late afternoon

HIGHLIGHTS:

• **The Painted Desert** is broadly defined as a region of desolate and beautiful Chinle formation in northeastern Arizona; a prime section is found in Petrified Forest National Park. Lyrical shapes and colors repeat in folds and ripples and long broad swells of glorious untouched earth. Nature as the artist has used the most delicate palette with the finest subtle gradations of tone—buff, coral, salmon, rose, cream, peach, tan, chocolate brown, sage green, slate blue, lavender, and grays of every shade. The motif is simple: Stripes, swaths, and broad strokes are everywhere, running their course from mesa to mesa.

• **Newspaper Rock,** massive boulders covered with ancestral Puebloan petroglyphs, can be seen from an overlook.

• **The Tepees,** wild badlands of furrowed cone-shaped formations, are colored by bands of carbon and oxides of manganese and iron.

• **Blue Mesa** offers views overlooking deep gray-blue clay hills and jumbled log falls.

• **Agate Bridge,** an enormous petrified log, lies across a 40-foot-wide ravine. More than 110 feet of this incredible stone bridge are exposed, although most of its length has been reinforced with concrete.

• **The Rainbow Forest District and Rainbow Forest Museum** offer wonderful displays of petrified wood as well as short, easy trails through frozen trees at the colorful Long Logs area, the Agate House (an ancient pueblo built entirely of petrified wood), and the Giant Logs, featuring "Old Faithful," the largest log in the park.

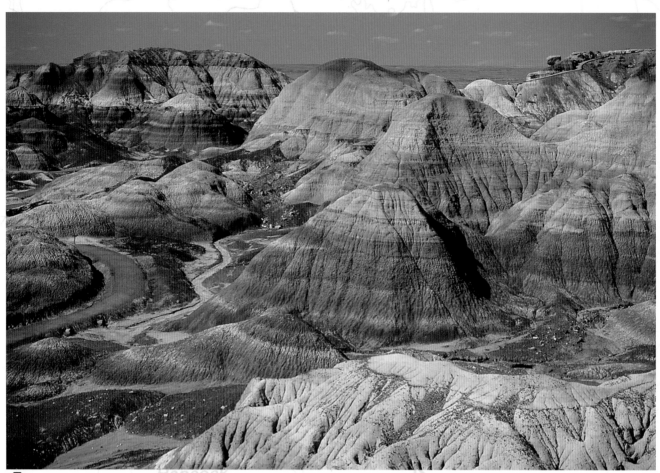

51 *From Blue Mesa*

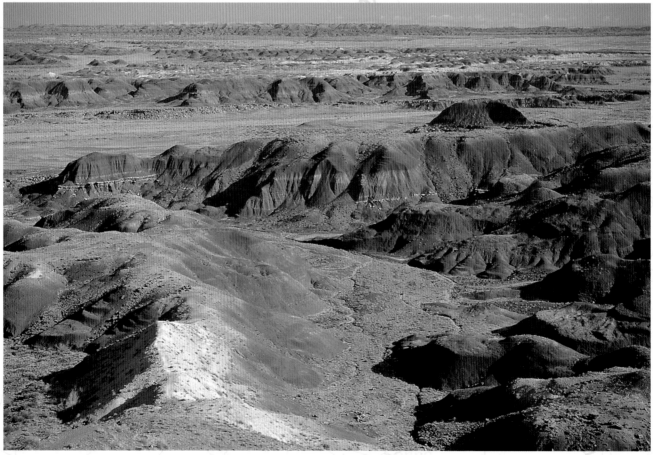

52 *From Chinde Point*

COLORFUL NOTE

Sadly, the National Park Service estimates that more than 12 tons of petrified wood are lost to theft each year.

GENERAL INFORMATION

FEE:	Yes	CONVENIENCE STORE:	Yes
VISITOR CENTER:	Yes	HIKING:	Yes
4WD NEEDED:	No	CAMPING:	Yes*
GAS WITHIN 5 MILES:	Yes	LODGING WITHIN 5 MILES:	No
RESTROOMS:	Yes	PHOTO RATING (1–5):	3
FOOD/WATER:	Yes	CHILD RATING (1–5):	4.5

*CAUTION: Overnight wilderness camping is allowed in certain areas but requires a permit, which can be obtained at no charge at either the Painted Desert Visitor Center or the Rainbow Forest Museum.

Petrified Forest National Park has a well-enforced zero-tolerance policy against the removal of *anything* from its original location, including even the smallest splinter of petrified wood. Visitors are urged to report those in violation of this federal law, and offenders will face significant fines and/or arrest. Protect fragile cryptobiotic soil by staying on pavement and marked trails only.

FOR MORE INFORMATION

Superintendent
Petrified Forest National Park
P.O. Box 2217
Petrified Forest, AZ 86028
(928) 524–6228
www.nps.gov/pefo

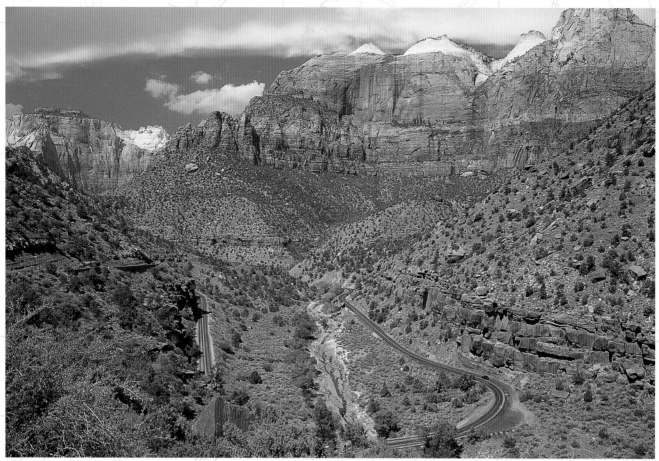

53 *Zion Canyon*

54 *Weeping Rock*

ZION
National Park

LOCATION: Southwestern Utah, near Springdale

ELEVATION: Ranges from 3,666 feet at Coalpits Wash to 8,726 feet at Horse Ranch Mountain

HEBREW NAME: *Zion*—"place of refuge or sanctuary"

PAIUTE NAME: *I-u-goone*—"the place where one must go out the way he came in"

AREA MAP

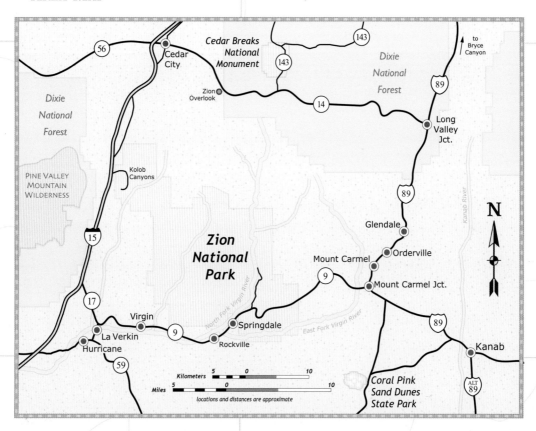

GEOLOGY: If the Grand Canyon were Father Time, then Zion Canyon must be Mother Earth. Spectacular and lush, this rocky gorge has been carved into the Markagunt Plateau by the powerful North Fork of the Virgin River, a tributary of the Colorado River. One-half mile wide and again as deep at its mouth, Zion Canyon gradually closes to a crack at the Narrows, where, at one point, its vertical walls rise 1,000 feet but are less than 20 feet apart. Tremendous Navajo sandstone masses and sculpted cliffs tower overhead, their remote edges weathering away to rugged slickrock, cracked and grooved, in creamy shades of burnt orange, pink, and white.

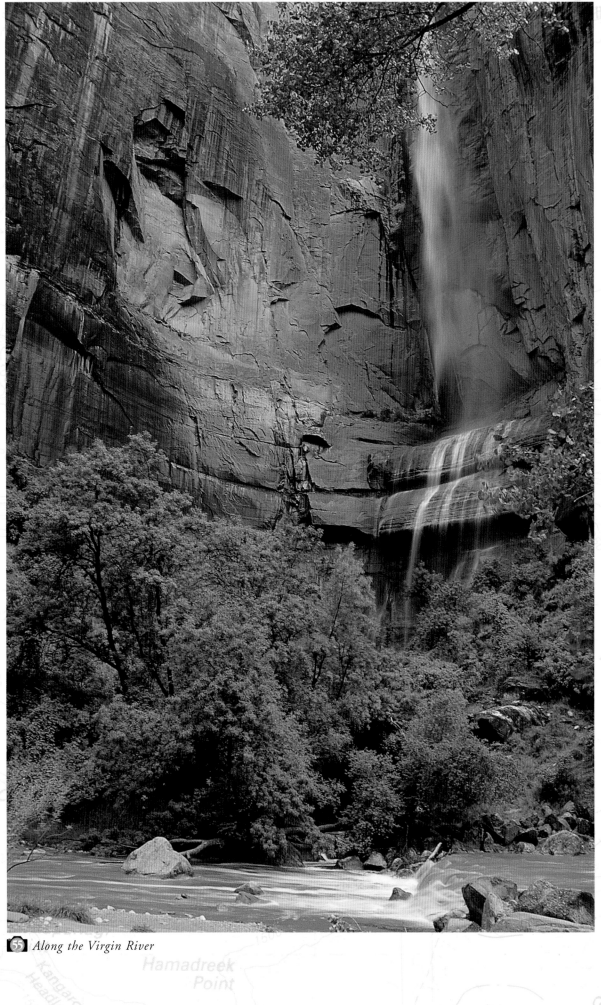

55 *Along the Virgin River*

ZION
National Park

LOCAL MAPS

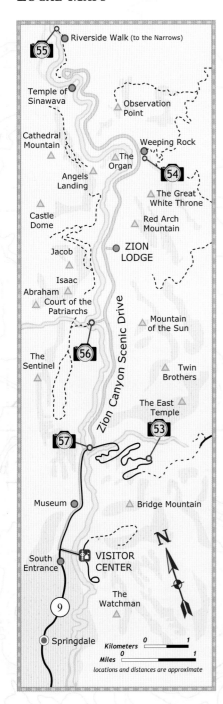

Riverside Walk (to the Narrows)
55
Temple of Sinawava
Observation Point
Cathedral Mountain
Weeping Rock
The Organ
54
Angels Landing
The Great White Throne
Castle Dome
Red Arch Mountain
Jacob
ZION LODGE
Isaac
Abraham
Court of the Patriarchs
Mountain of the Sun
56
Twin Brothers
The Sentinel
The East Temple
53
57
Museum
Bridge Mountain
South Entrance
VISITOR CENTER
N
The Watchman
9
Springdale

Zion Canyon Scenic Drive

Kilometers 0 1
Miles 0 1
locations and distances are approximate

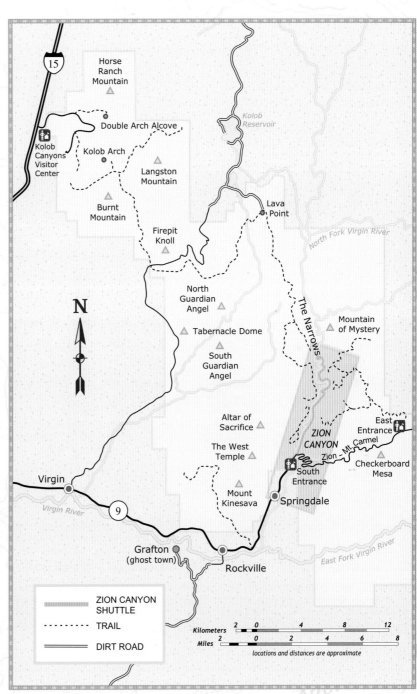

15
Horse Ranch Mountain
Double Arch Alcove
Kolob Reservoir
Kolob Canyons Visitor Center
Kolob Arch
Langston Mountain
Burnt Mountain
Lava Point
North Fork Virgin River
Firepit Knoll
North Guardian Angel
The Narrows
Mountain of Mystery
N
Tabernacle Dome
South Guardian Angel
Altar of Sacrifice
ZION CANYON
East Entrance
The West Temple
Zion - Mt. Carmel
Checkerboard Mesa
Virgin
South Entrance
Mount Kinesava
Springdale
Virgin River
9
Grafton (ghost town)
Rockville
East Fork Virgin River

━━━━ ZION CANYON SHUTTLE
- - - - TRAIL
━━━━ DIRT ROAD

Kilometers 2 0 4 8 12
Miles 2 0 2 4 6 8
locations and distances are approximate

115

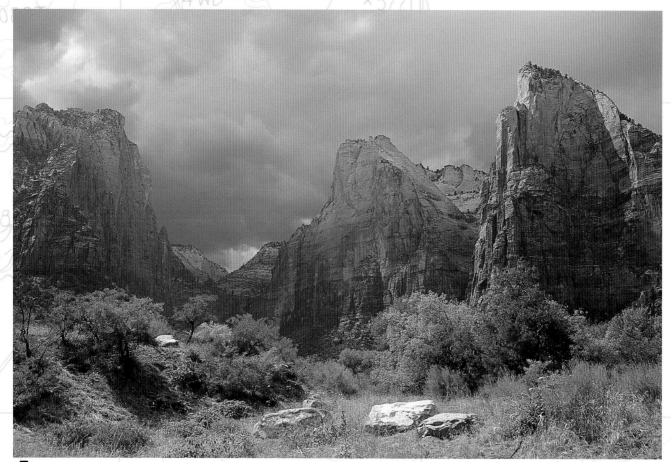

56 *Court of the Patriarchs*

Pinecones

SUGGESTED LENGTH OF STAY: 2 to 4 days

BEST TIME TO BE THERE: Early November, when autumn makes its way down through the canyon, and the Fremont cottonwoods, bigtooth maples, box elders, and ash blaze in brilliant crimson and gold

HIGHLIGHTS:

• **Angels Landing and Trail** (5,990 feet): A very steep and strenuous 5-mile round-trip climb ascends from the Grotto to the top of Angels Landing, which can be frightening to those fearful of heights. This trail is not recommended for young children.

• **Checkerboard Mesa** (6,670 feet): Huge petrified sand dunes have been etched over the ages with a striking pattern of crosshatched lines and grooves cracked open during expansion and contraction.

• **The Great White Throne** (6,744 feet): This giant monolith flanks the east wall of the canyon, white at the top and gradually becoming red near the base due to the presence of iron oxide in the rock.

• **Kolob Arch:** A strenuous 14-mile round-trip hike through Kolob Canyons leads to a freestanding natural arch with a span of 310 feet.

• **Riverside Walk:** An easy paved trail follows the Virgin River from the Temple of Sinawava past hanging gardens and waterfalls to the beginning of the Narrows, deep within the canyon. Hiking beyond this point into the river at the Narrows requires a walking stick and must not be attempted if flash-flood danger exists.

• **Temple of Sinawava:** Located at the north end of Zion Canyon Scenic Drive, this vast natural amphitheater is surrounded by sheer canyon walls with two stone formations—the Altar and the Pulpit—at its center.

• **Virgin River:** Usually winding like a creek along the fertile canyon floor, this gentle river can turn violent during a flash flood, demonstrating with volume and velocity its canyon-cutting power.

• **The Watchman** (6,545 feet) and **The West Temple** (7,810 feet): These two mammoth rock landmarks guard the southern entrance of the park.

• **Weeping Rock:** Water filters through sandstone to reach the denser shale where it seeps out, dripping onto lush hanging gardens of flowers and ferns that cling to the rearing canyon walls.

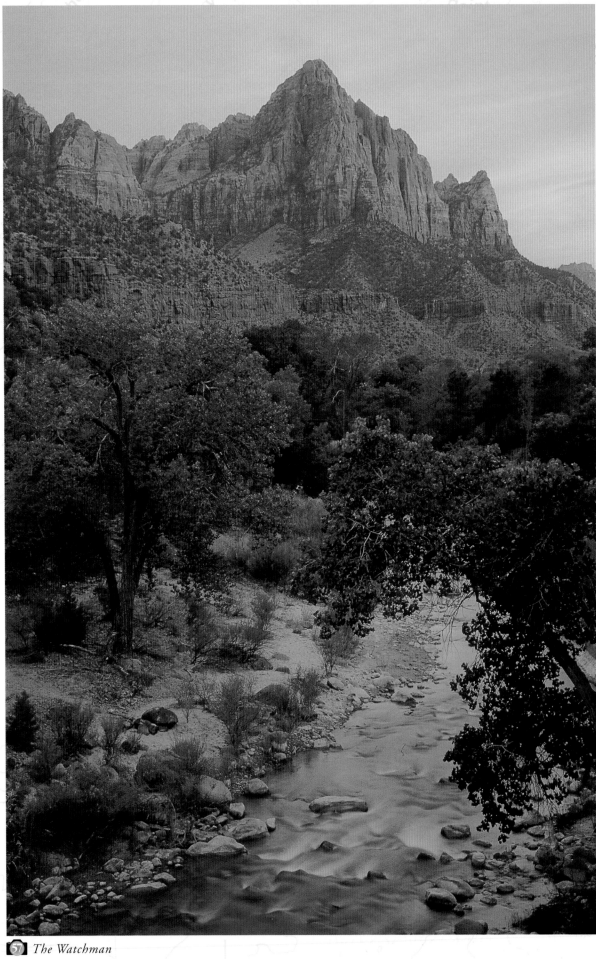

57 *The Watchman*

• **Zion–Mt. Carmel Highway:** Built for beauty, not speed, this miracle of engineering winds its way to Zion Canyon for 13 miles round trip from the southern entrance or 22 miles round trip through the Zion Tunnel from the east entrance. From April through October, access into the canyon via Zion Canyon Scenic Drive is by free shuttle bus only, with departures from the visitor center and from the town of Springdale. From November through March, the road is open to private vehicles, with parking and access provided for the trailheads to Weeping Rock, Emerald Pools, and the Gateway to the Narrows.

COLORFUL COMMENT

THERE IS AN ELOQUENCE TO THEIR FORMS WHICH STIRS THE IMAGINATION WITH A SINGULAR POWER AND KINDLES IN THE MIND . . . A GLOWING RESPONSE. . . . NOTHING CAN EXCEED THE WONDROUS BEAUTY OF ZION . . . IN THE NOBILITY AND BEAUTY OF THE SCULPTURES THERE IS NO COMPARISON.

—CLARENCE E. DUTTON, geologist, 1880

GENERAL INFORMATION

FEE:	Yes	CONVENIENCE STORE:	Yes
VISITOR CENTER:	Yes	HIKING:	Yes
4WD NEEDED:	No	CAMPING:	Yes
GAS WITHIN 5 MILES:	Yes	LODGING WITHIN 5 MILES:	Yes
RESTROOMS:	Yes	PHOTO RATING (1–5):	4.5
FOOD/WATER:	Yes	CHILD RATING (1–5):	3.5

CAUTION: Hike with caution on steep slopes with sheer drop-offs, or at high elevations where lightning may strike. Flash floods may occur without warning.

FOR MORE INFORMATION

Superintendent
Zion National Park
SR 9
Springdale, UT 84767-1099
(435) 772–3256
www.nps.gov/zion

Creek

Horse

Horse

Mollys
Castle

Buckskin
Spring

GOBLIN VALLEY

STATE PARK